BLUE RIDGE MOUNTAINS
America's First Frontier

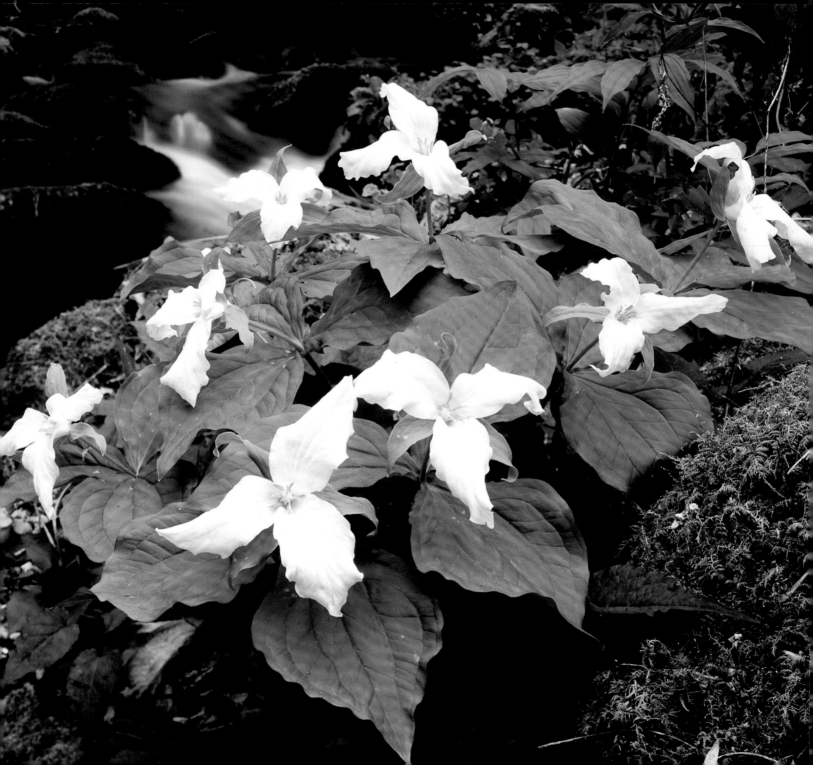

BLUE RIDGE MOUNTAINS
America's First Frontier

JERRY D. GREER

Foreword by Donald Davis

Mountain Trail Press

1818 Presswood Road • Johnson City, Tennessee 37604
www.mountaintrailpress.com

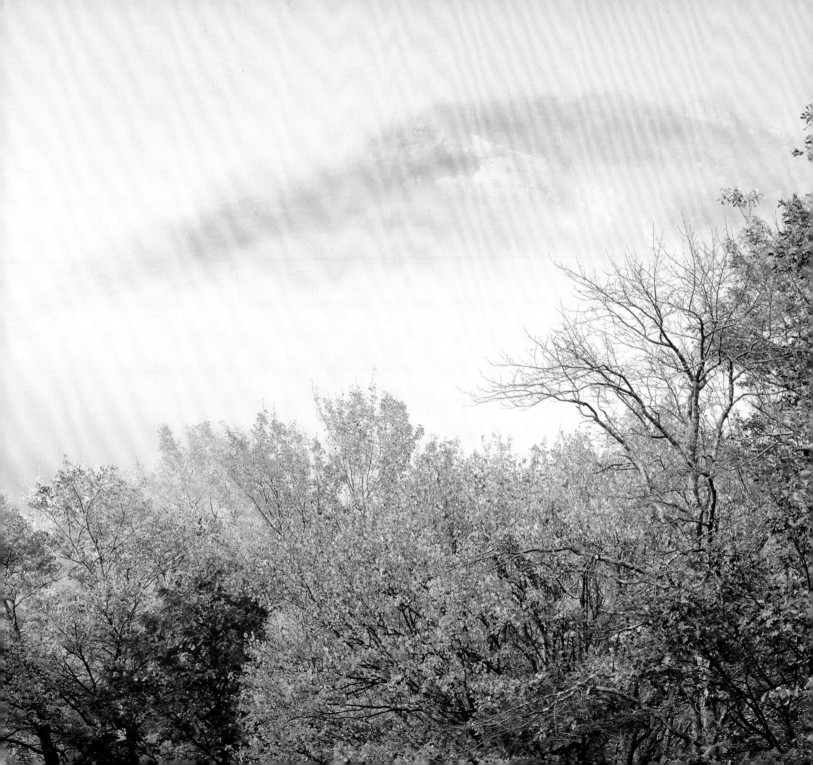

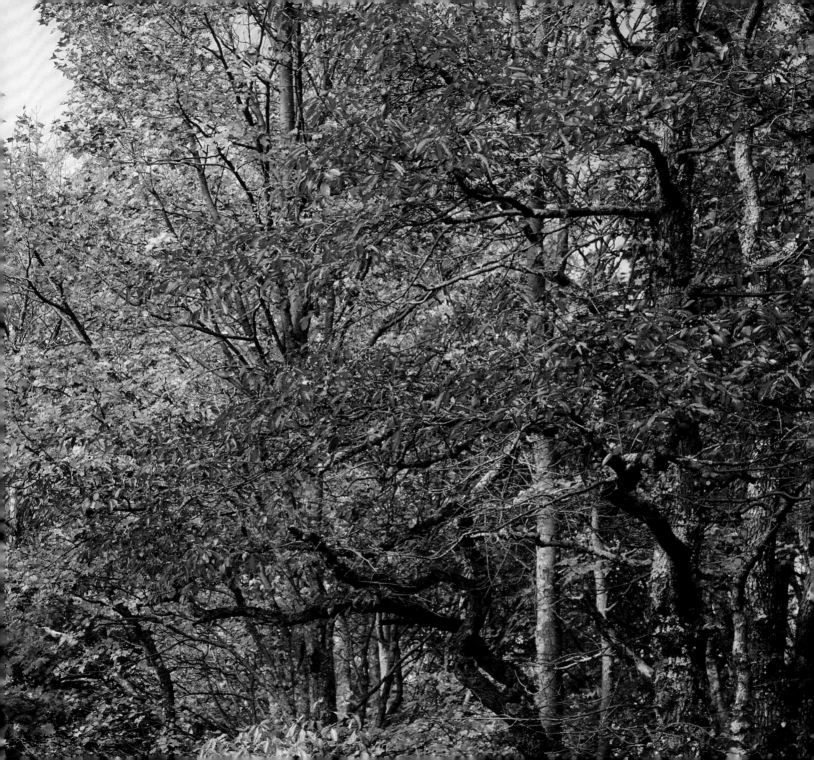

BLUE RIDGE MOUNTAINS
America's First Frontier

JERRY D. GREER
Foreword by Donald Davis

Book design: Jerry and Angela Greer
Editor: Todd Caudle
Entire Contents Copyright © Mountain Trail Press 2004
Photographs Copyright © Jerry D. Greer 2004
All Rights Reserved
No part of this book may be reproduced in any form
without written permission from the publisher.

Published by Mountain Trail Press
1818 Presswood Road
Johnson City, TN 37604

ISBN: 0-9676938-4-5
Printed in Korea
First printing, Spring 2004

Front cover: Evening vista at Blackrock Summit, as viewed from the Appalachian Trail, Shenandoah National Park in Virginia.
First frontispiece: White trillium and spring cascade, Porters Creek Trail, Great Smoky Mountains National Park, Tennessee and North Carolina.
Second frontispiece: An autumn storm retreats from the slopes of Grandfather Mountain in North Carolina. Grandfather Mountain is recognized as an International Biosphere Reserve and provides habitat for more rare species than any mountain east of the Rockies.
Back cover: Autumn cascade, Middle Prong of the Little River at Tremont, Great Smoky Mountains National Park, Tennessee and North Carolina. For the first three decades of the 1900's, the Little River Lumber Company began sawing, skidding, and hauling away one of the greatest virgin forests on earth.
Right: Mabry Mill in winter decor, Blue Ridge Parkway, Virginia.

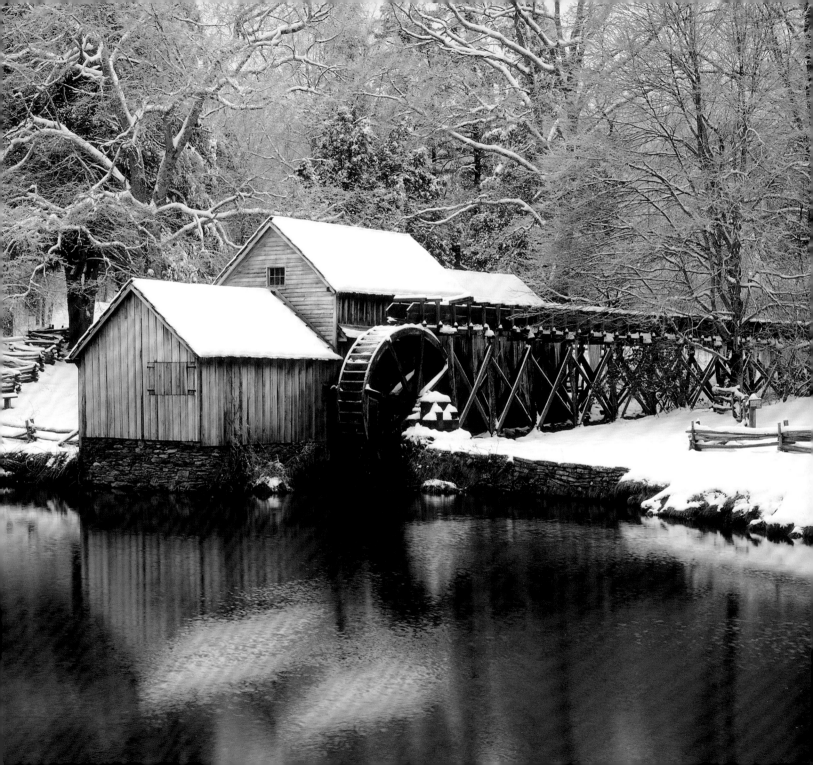

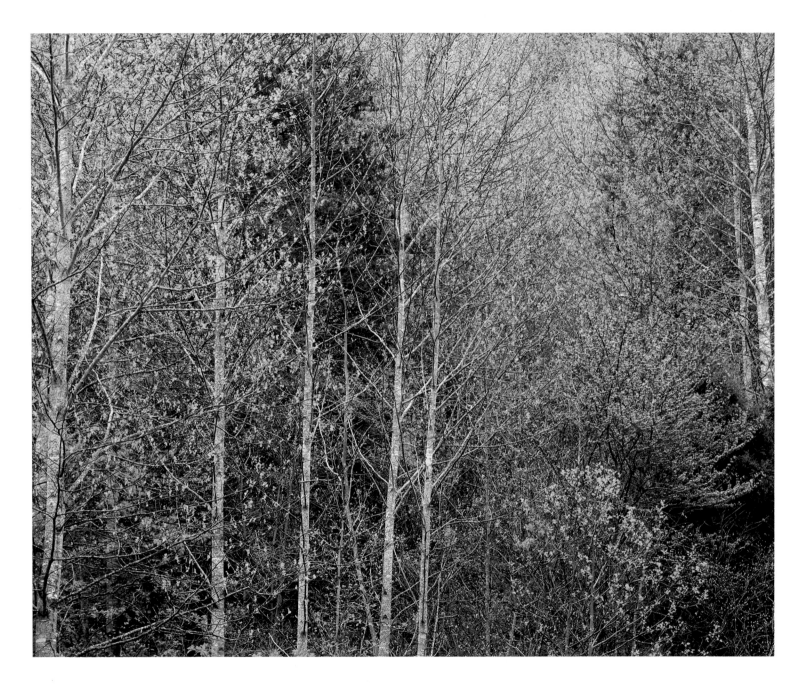

The bright magenta blooms of the redbud tree are an early spring treat,
Chattahoochee National Forest, Georgia

Foreword

In the early part of the eighteenth century, political changes in the British Isles began to set in motion a population shift that resulted in a very particular kind of first settlement of the Blue Ridge highlands of the Appalachian mountain range. The essence of this political change was that the Parliament of England co-opted the Parliament of Scotland. The emotional result was a deep feeling in the hearts of the people of loyal Scottish identity that their world had been stolen . . . they no longer had a country, a heart-home. It was those most loyal Scots who began to leave behind their "stolen" homeland, not in order to seek fortune, but in order to maintain their own deepest identity. The resulting immigration brought thousands of Scottish immigrants to America looking for a new home.

They came looking for two things: a place far away from government so that they could be who they were and be left alone, and, what all dislocated people seek, a place that looked like home.

Along the blue ridges of the Appalachian highlands, those dislocated Scottish people found heaven. The mountains they met looked like home, but even better. They were higher and more vast, they were unsettled by European claimants, they looked the way Scotland must have looked in long times past. And . . . they were no longer within reach of the English government's interference.

Not looking for fortune, but for a place to recover and hold on to their identity, these earliest of European settlers to the Blue Ridge built cabins, cleared small spots for subsistence farming, hunted and fished, played music, told old and new stories, danced, wove and quilted, preserved the foods they produced, and made whiskey . . . all the things they had done before leaving their ancestral home to come to this heavenly place. When they looked at the mountain world surrounding their new homeland, every single thing that they needed was already there.

This sense of the total completeness of their environmental world, a world that called for complementary living rather than developmental exploitation, was a life-sense these particular early settlers shared with the native Cherokee people who were sometimes found, not deep in the mountains then, but in the broad valleys on the shoulders of these highlands. Scot and Cherokee both regarded this world as heavenly. As my old neighbor in Cherokee County, North Carolina, Mr. John Christy, once declared to me, "When I die I'm not going to Heaven if it's on the other side of Topton! I'll just stay right here."

Today we are being challenged to realize the importance of this attitude of care and appreciation for a place that, in the generations between early settlement and now, has been often exploited, abused, used, mistreated and disrespected by new arrivals who came as fortune seekers rather than as caretakers.

We are now beginning to realize that both Scottish settlers and Cherokee natives had it right - the Blue Ridge Mountains are part of the top floor of Heaven. They need nothing added and nothing taken away. These mountains ask us to simply fit in, love, care, and enjoy appreciatively.

The gift of Jerry Greer's photography, for me, is that in visual immersion through his images, present time fades away. Look slowly and deeply, and, perhaps, you too can walk through these photographs into the time in which the Blue Ridge was America's First Frontier.

—Donald Davis
Ocracoke Island, North Carolina

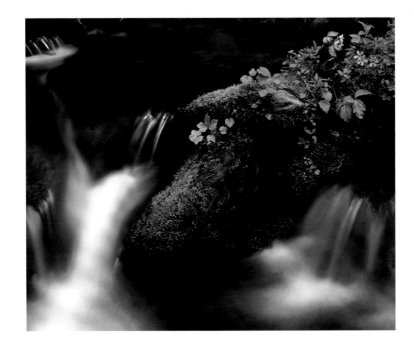

Signs of spring return to the streams of the Blue Ridge, Mountain Bridge Wilderness, South Carolina

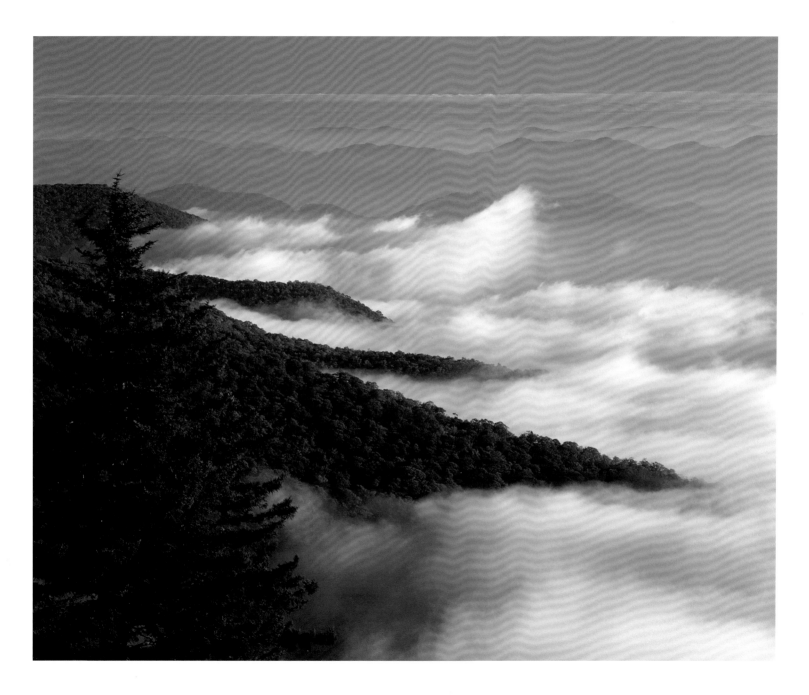

A foggy September morning view, from the Blue Ridge Parkway in North Carolina.

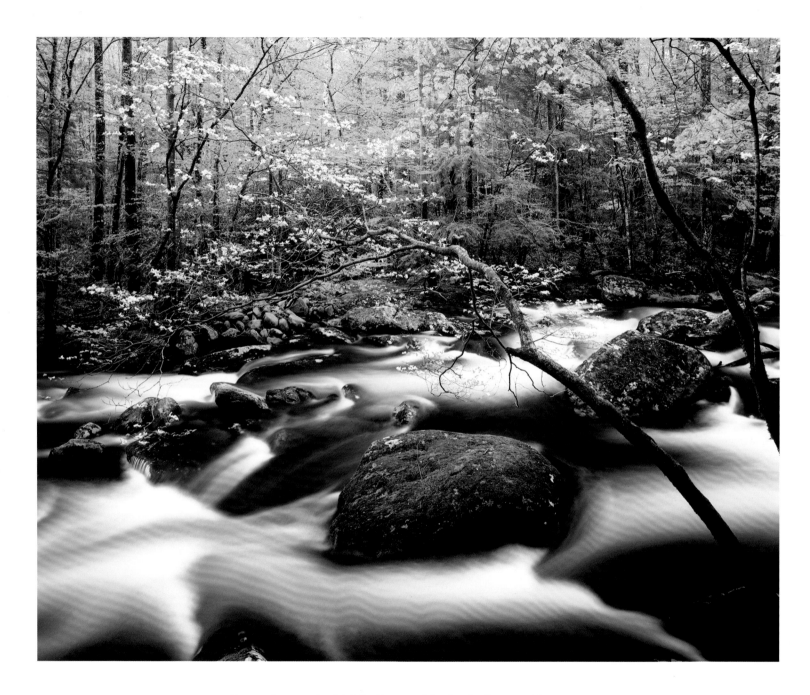

Spring flow in the Middle Prong of the Little River at Tremont,
Great Smoky Mountains National Park, Tennessee and North Carolina.

Introduction

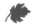

America's first frontier. What a powerful statement! When one thinks of "frontier," the first thing that often comes to mind is the American West. However, the Blue Ridge Range was already ancient when the Rockies, Sierras and Cascades arose in the West. These mountains, known to the Cherokee as the Blue Wall, are the easternmost ridge of the southern Appalachians. The Blue Ridge is part of the oldest mountain chain in the world, with its bedrock dating from the Pre-cambrian and early Paleozoic eras over one *billion* years ago. Since that time, erosion has sculpted their once-formidable form to its smooth and rounded frame of today.

For over 150 years, the rugged and densely forested Blue Ridge Mountains were a land into which non-natives from the East did not dare to venture. It wasn't until the 1750s that the pioneers began settling along the mountain valleys of the Blue Ridge. Once conquered, the drive west was underway.

The lore of the Cherokee, as well as that of early explorers and settlers of the Blue Ridge, seems as ancient as the mountains themselves. There is a rich history that has been handed down by mountain families for generations in the form of old stories, myths and legends, folk art and crafts, old songs and music, and spoken of in church pews, barns and by the warm light of the hearth. Present day Blue Ridge families whose ancestors have lived in these ancient mountains for generations celebrate an ongoing love affair with these old hills; the mountain spirit is forever entrenched in all who were raised here. Some depart these mountains for a time, but just as my

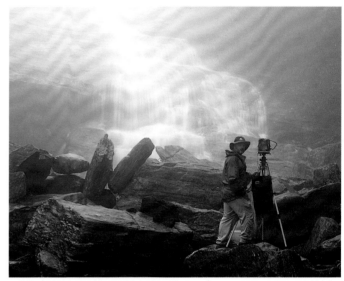

Photo by Todd Caudle

wife Angela and I did, most return to the beloved Blue Ridge, for there is something about these old mountains that seems to draw us home.

Indeed, the publication of *America's First Frontier* is a homecoming of sorts for me. This book consists of a selection of photographs that is the quintessence of where I was born and raised, a place that, for a time, I sometimes felt too sheepish to admit that I called home. This was around the time I left the southern Appalachians for the high mountains of the Colorado Rockies, where I feared my Western friends would look down their noses at this born-and-raised Southern boy. Angela and I came to love the Rockies, but after a few years out west, we found ourselves drawn back to our

ancestral homeland. Nowadays, I can't imagine myself living anywhere but in the shadow of the Blue Wall.

My first book, *Appalachia — The Southern Highlands*, was the beginning of my rediscovery of my homeland. This book is a continuing celebration of that rediscovery. I invite you, through the pictures in this book, to vicariously walk with me across the ridges and through the valleys of the Blue Ridge Mountains. Imagine the fragrance of the ancient forest and the cool waters flowing along the mountain streams, just as I did as I captured each image in this portfolio. This is my world when I am at work; this is the work of my life. I am a landscape photographer and the spirit of the landscape is my passion. I hope you will have the occasion to personally revel in the spirit of these mountains and experience their ancient past. In so doing, my wish is that you will take the mountain spirit to heart and help protect these mountains for the many generations to come. As Aldo Leopold wrote, "When we see land as a community to which we belong, we may begin to use it with love and respect."

—Jerry D. Greer
Johnson City, Tennessee

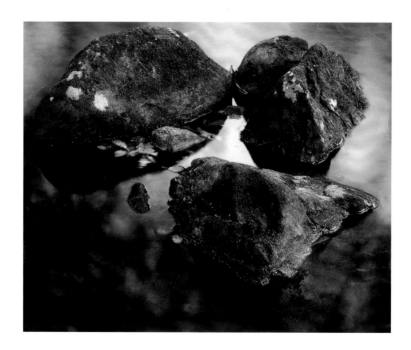

Autumn hues reflect in the Cullasaja River, Cullasaja River Gorge, North Carolina

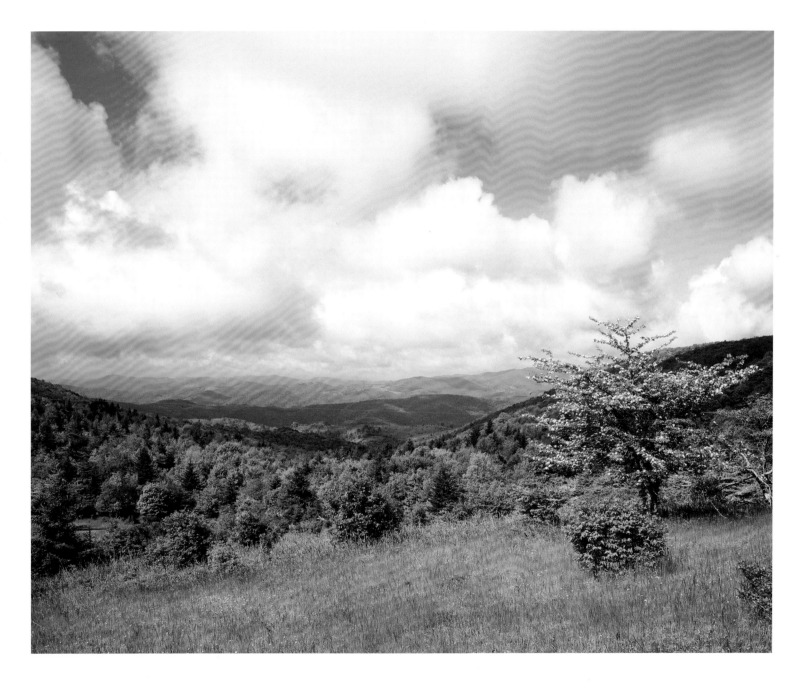

Summer vista over the Virginia Highlands, as viewed from Massie Gap,
Grayson Highlands State Park in Virginia.

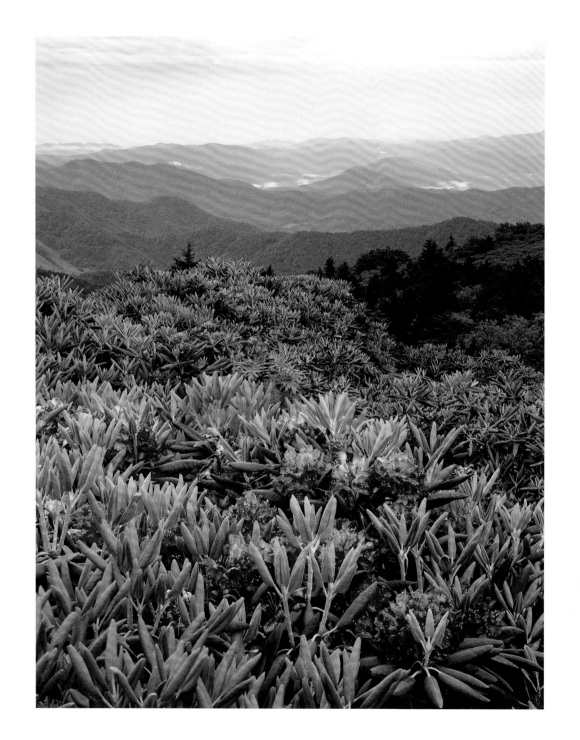

Catawba Rhododendron blooms
in abundance along the slopes of
the Roan Highlands, Tennessee
and North Carolina.

Flame azalea in colorful
brilliance, Roan Highlands in
Tennessee and North Carolina.

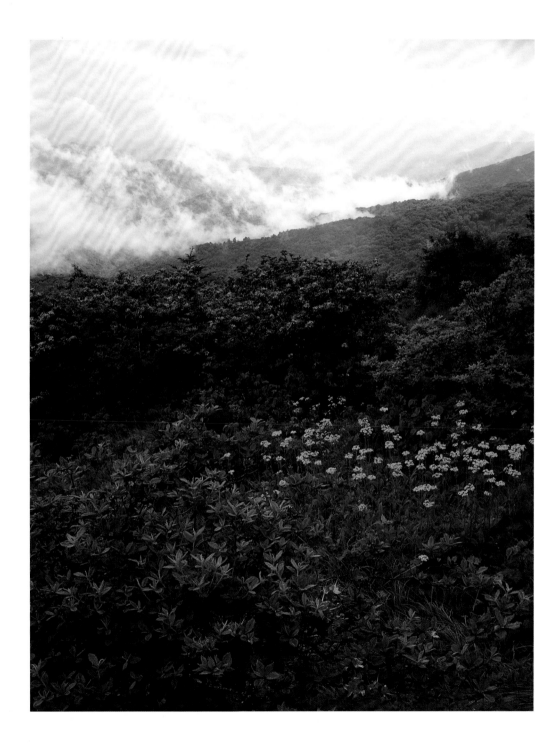

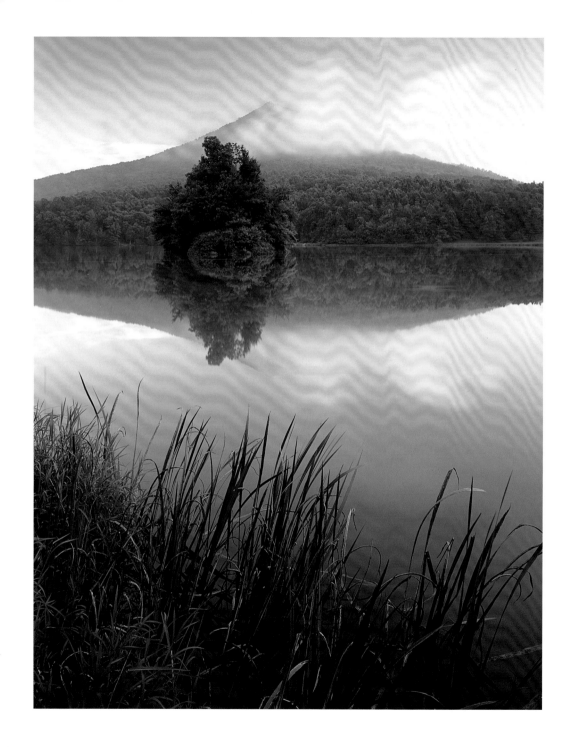

Sharp Top Peak reflects in
Abbot Lake, Peaks of Otter,
along the Blue Ridge Parkway
in Virginia.

Rock island reflection along the
James River, James River Face
Wilderness in Virginia.

Overleaf: Winter vista over the
Bald Mountains, Cherokee
National Forest, Tennessee.

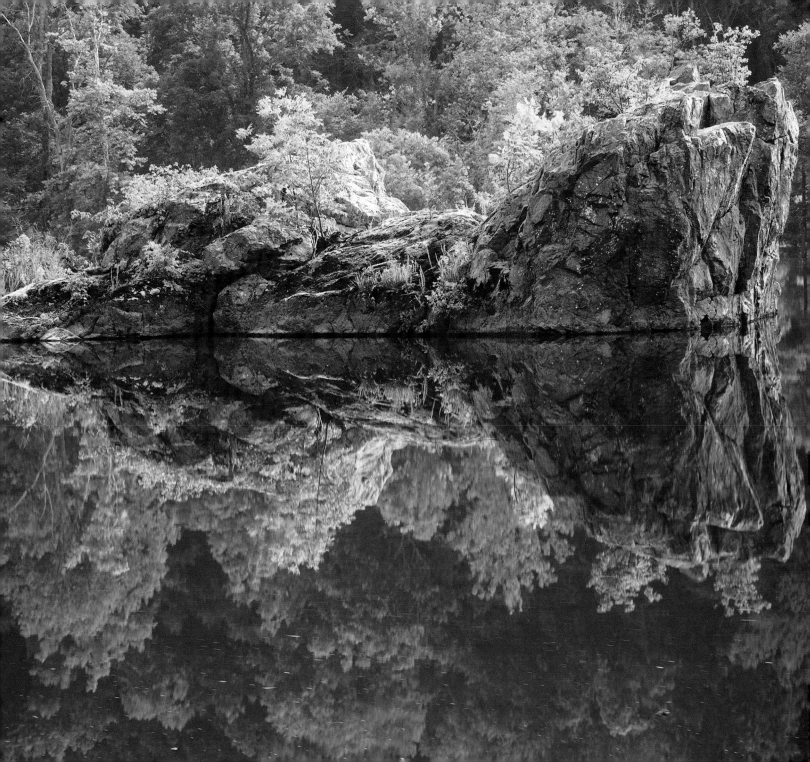

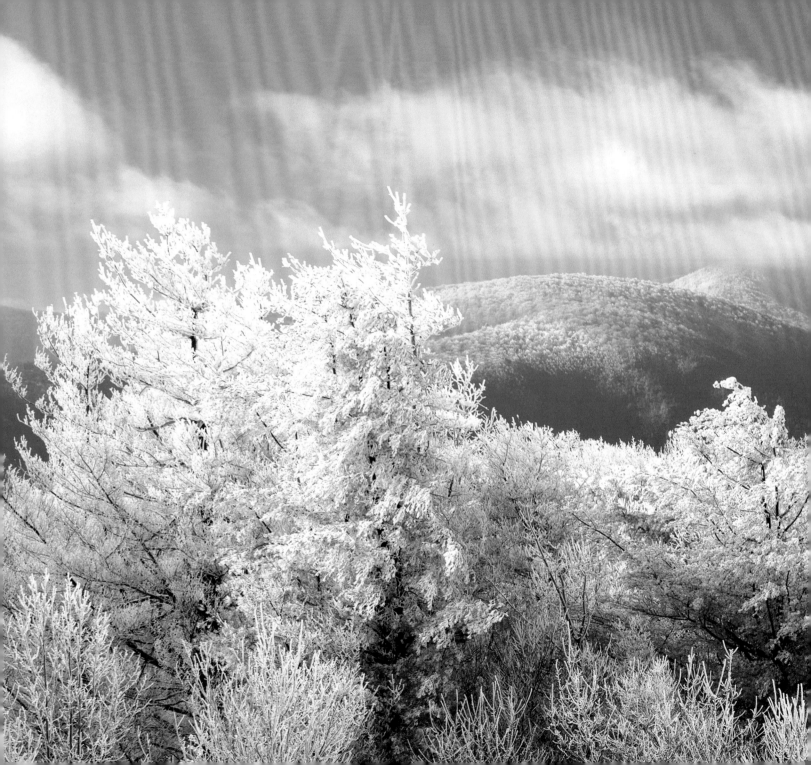

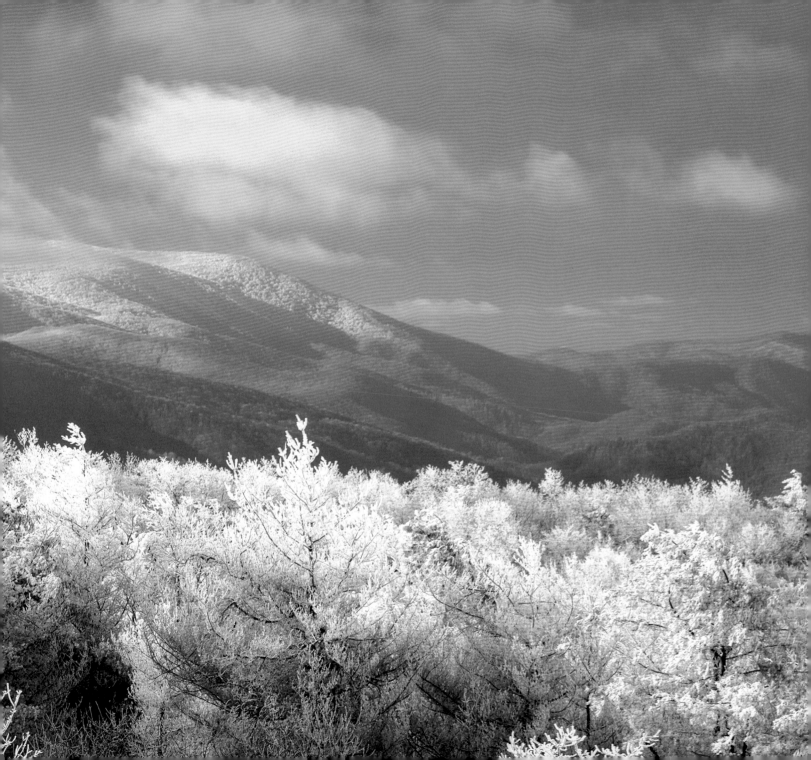

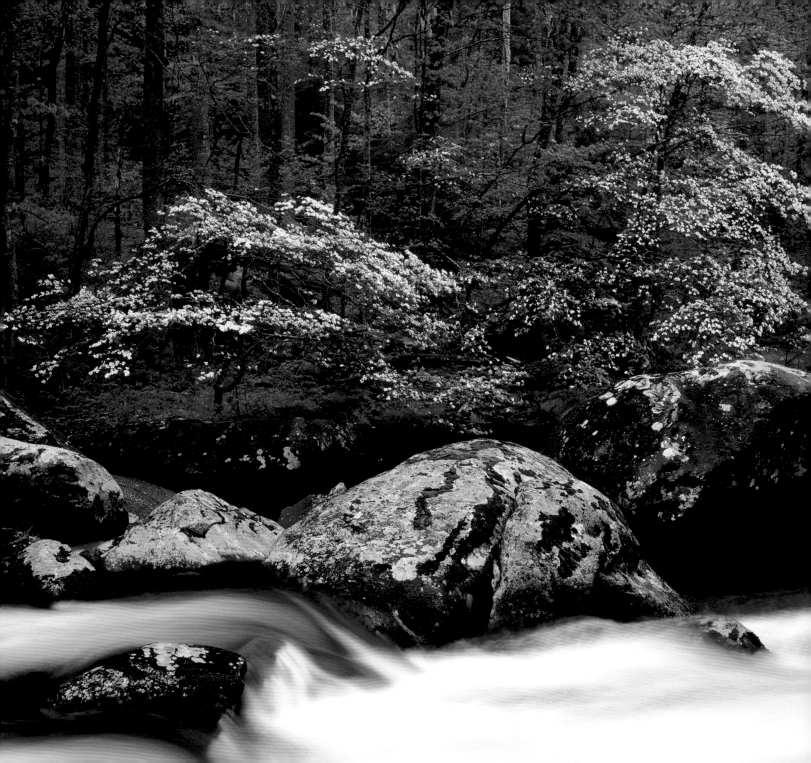

In early spring the flowering dogwoods dot the forest along the Middle Prong of the Little River at Tremont, Great Smoky Mountains National Park, Tennessee and North Carolina.

Autumn paints the mountain streams with artistic flair, Jefferson National Forest, Virginia.

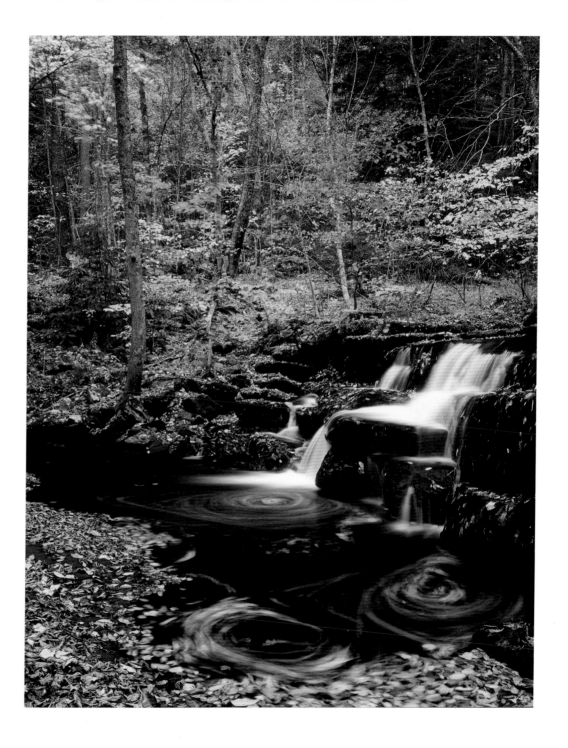

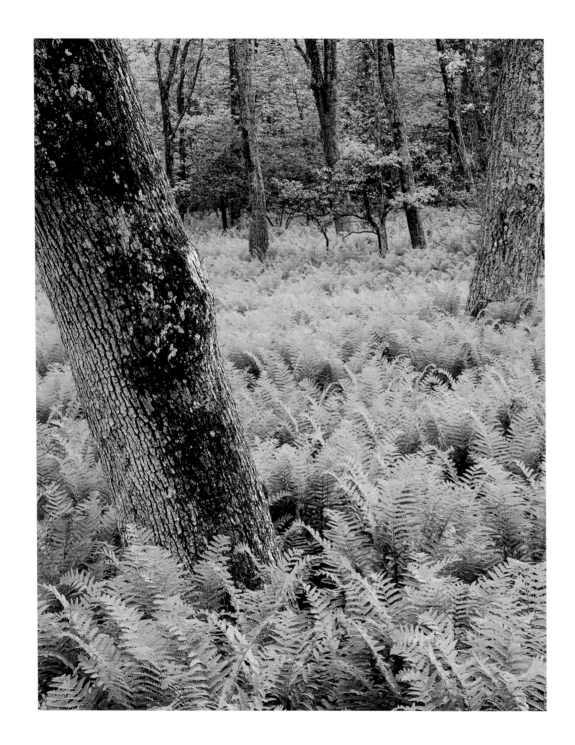

Spring forest, Shenandoah
National Park of Virginia.

Beech bole in a spruce and fir forest, Appalachian Trail, Unaka Mountains, along the Tennessee and North Carolina state line.

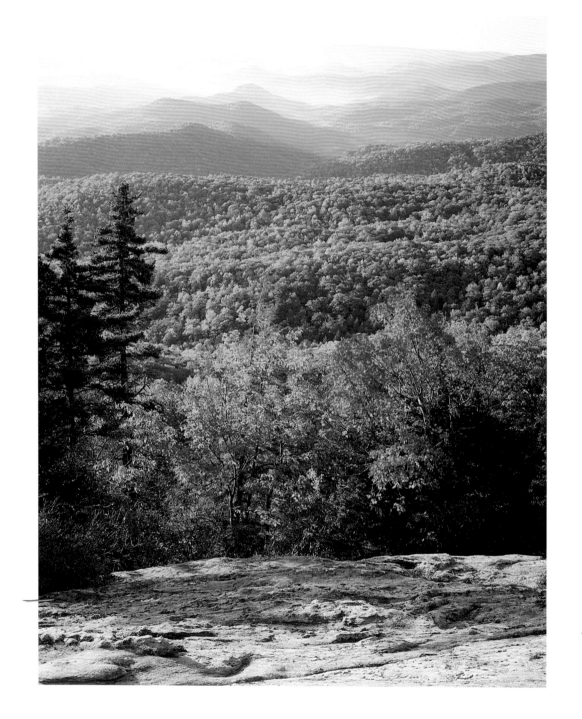

An incredible autumn vista from
Beacon Heights, Blue Ridge
Parkway, North Carolina.

A summer vista of the Highlands
from Jane Bald, Roan Highlands,
Tennessee and North Carolina.

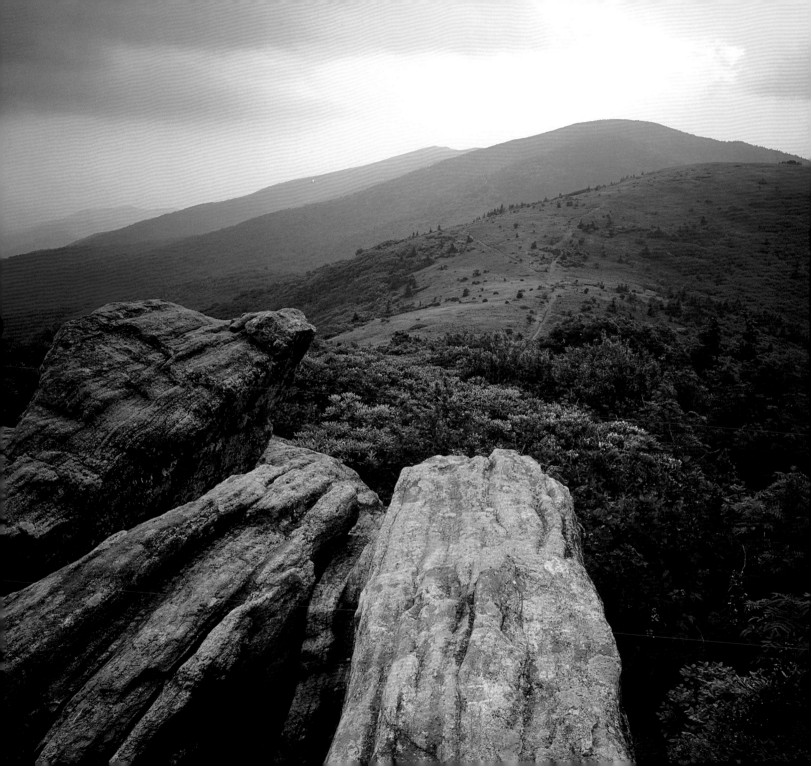

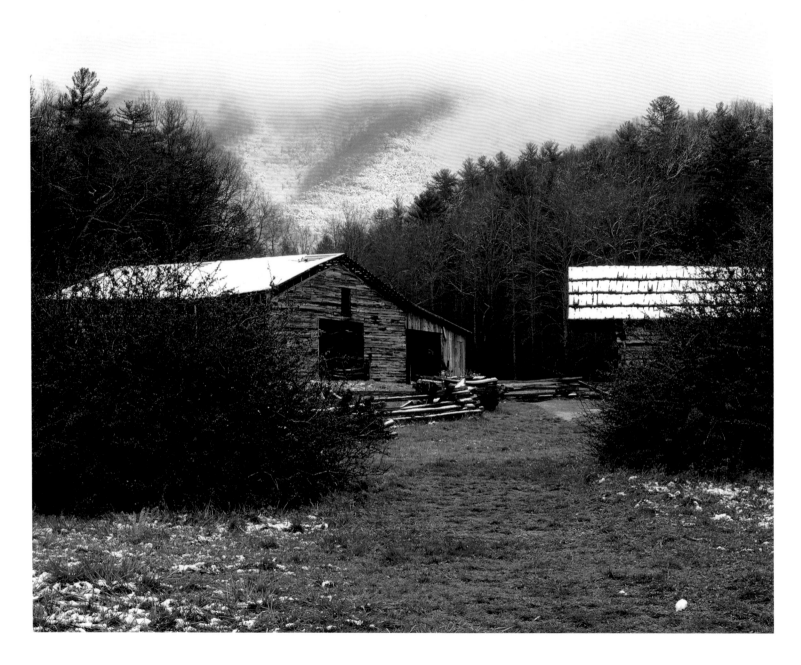

Spring snow covers the mountain ridges above the Dan Lawson Place in Cades Cove,
Great Smoky Mountains National Park, Tennessee and North Carolina.

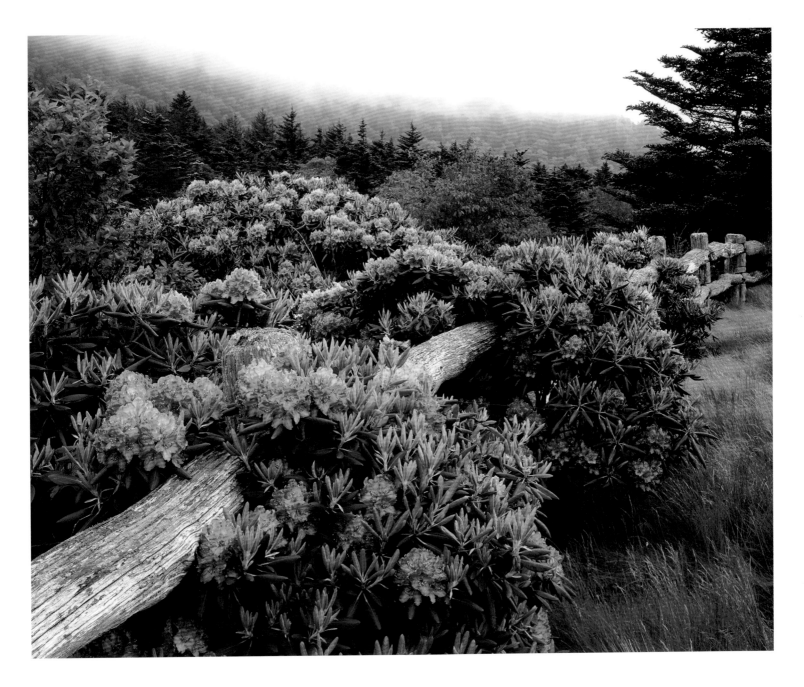

Blooming rhododendron and an old post fence, along the Roan
Highlands of Tennessee and North Carolina.

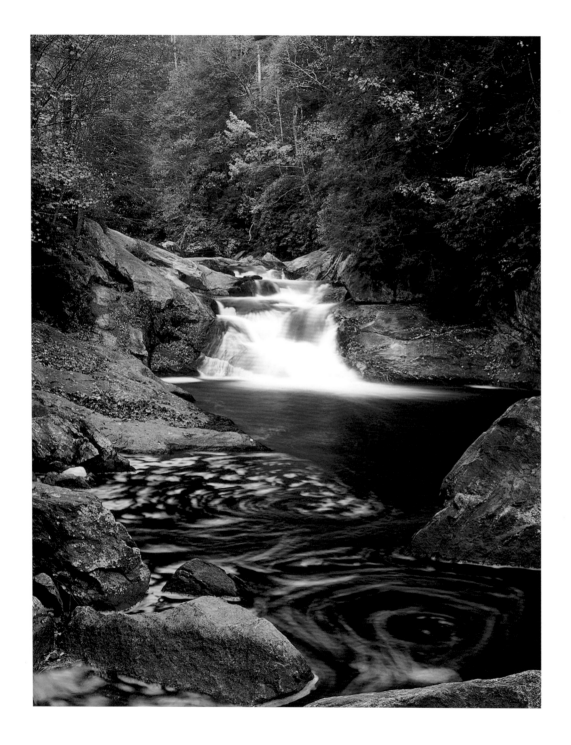

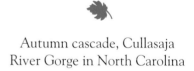

Autumn cascade, Cullasaja
River Gorge in North Carolina

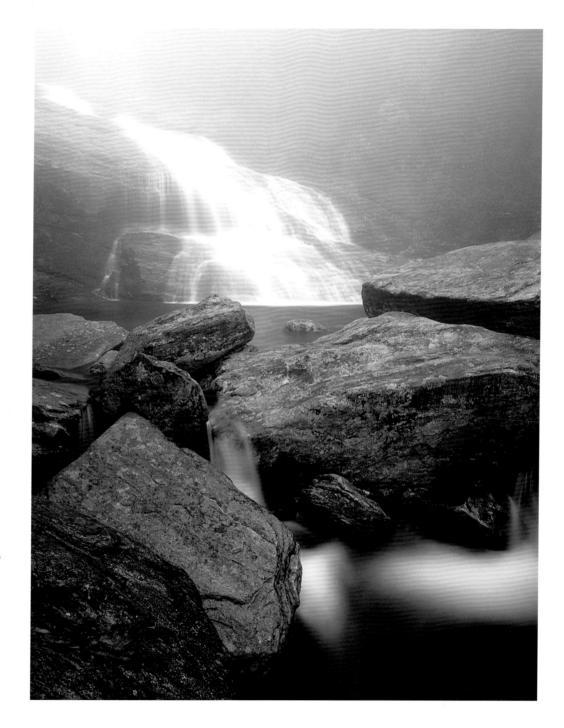

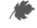

Second Falls of Yellowstone Prong,
Graveyard Fields, Pisgah National
Forest in North Carolina.

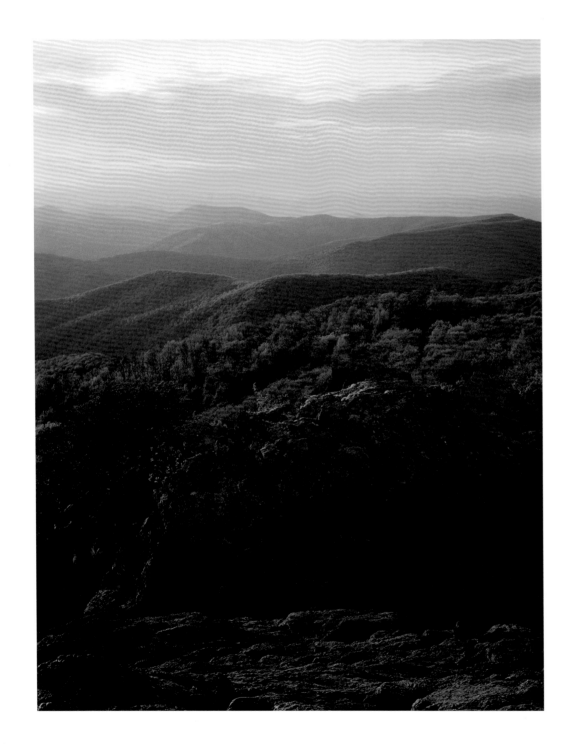

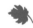

A spring evening on Bearfence
Mountain, Shenandoah
National Park, Virginia.

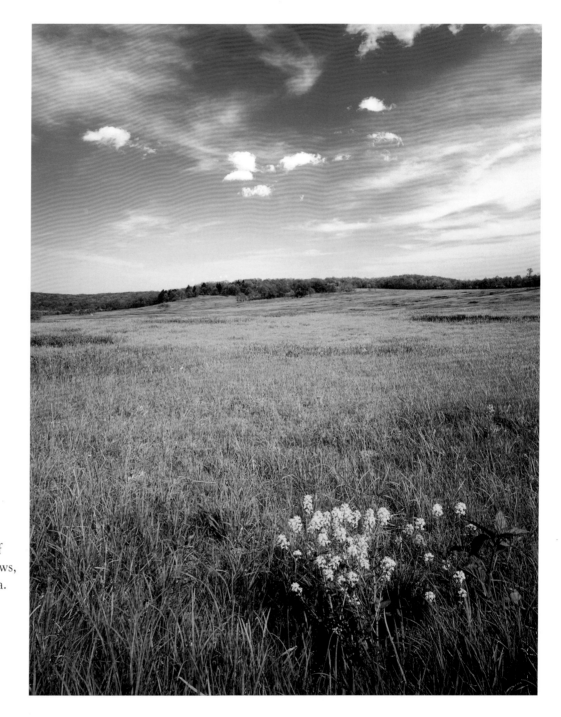

Common winter cress adds spots of yellow to the landscape of Big Meadows, Shenandoah National Park, Virginia.

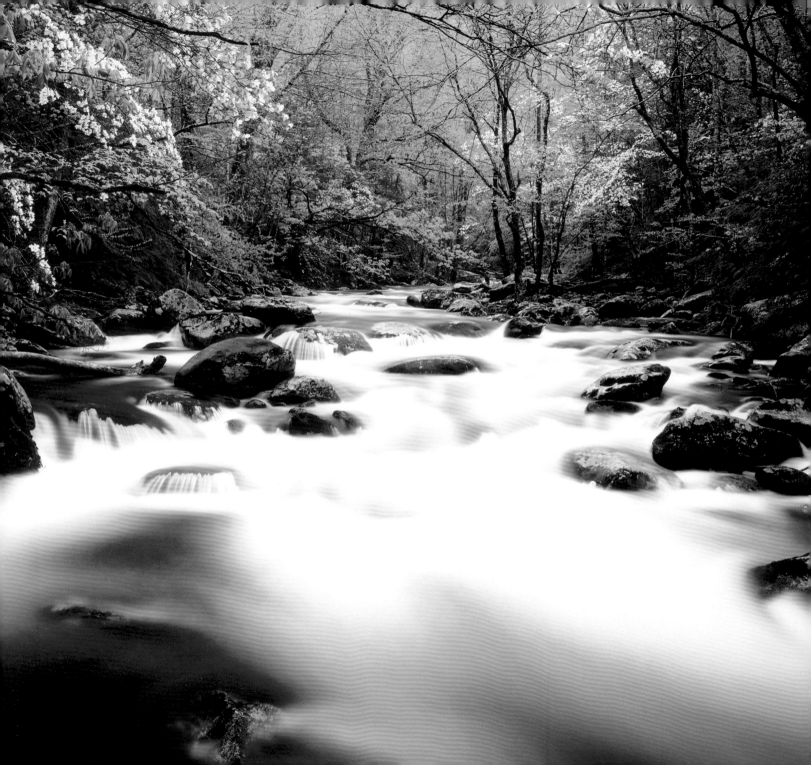

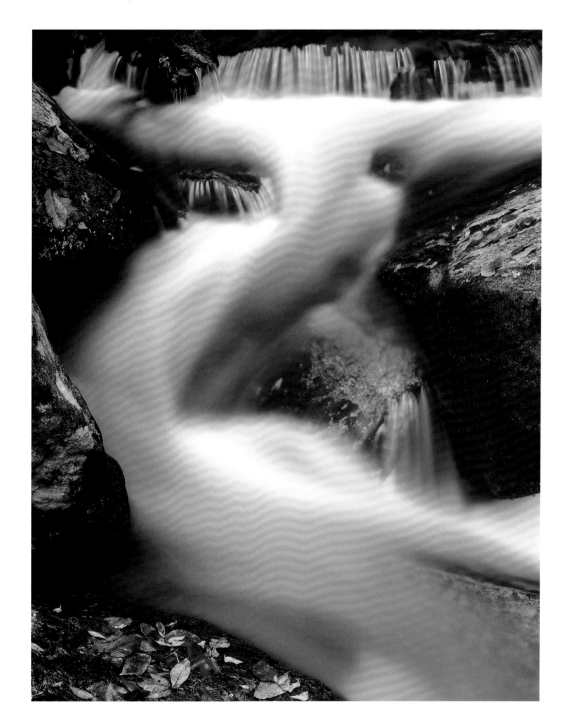

Spring stream, Middle Prong of
the Little River, Great Smoky
Mountains National Park,
Tennessee and North Carolina.

Autumn cascade detail along the
Middle Saluda River, Jones Gap
Trail, Jones Gap State Park
in South Carolina

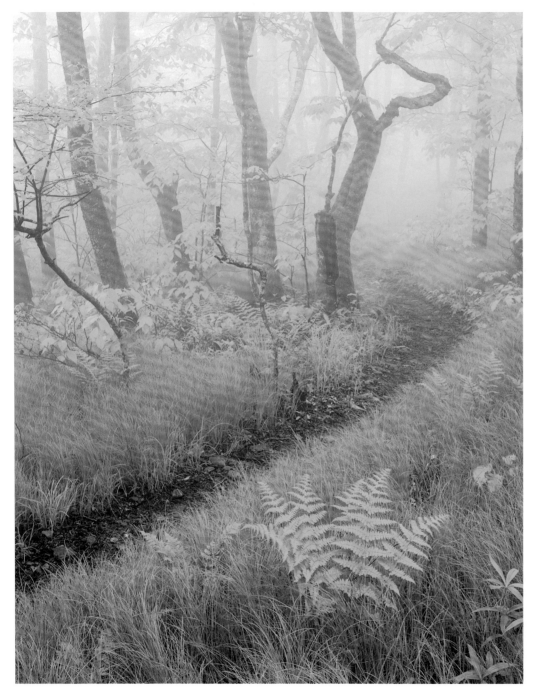

A spring beech forest colors the
landscape in bright green,
Appalachian Trail, Unaka Mountains
in Cherokee National Forest,
Tennessee.

New fern growth along the
Rainbow Falls Trail, Great Smoky
Mountains National Park,
Tennessee and North Carolina.

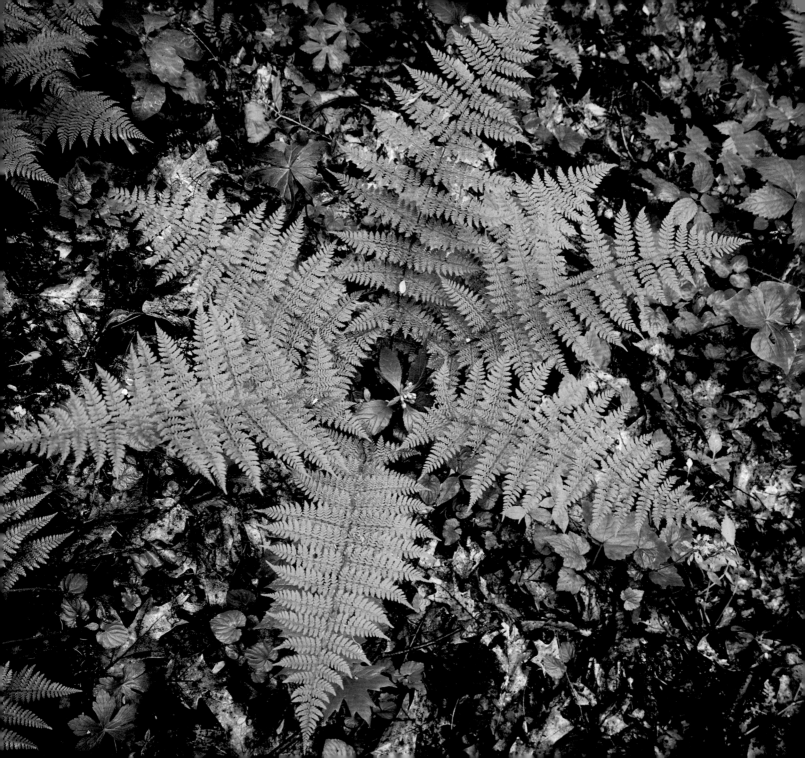

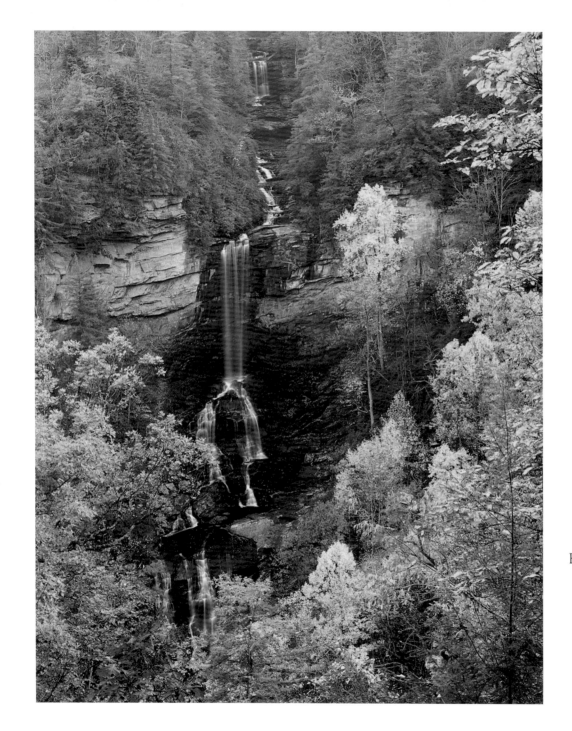

Fall foliage frames Raven Cliff Falls,
Caesars Head State Park,
South Carolina.

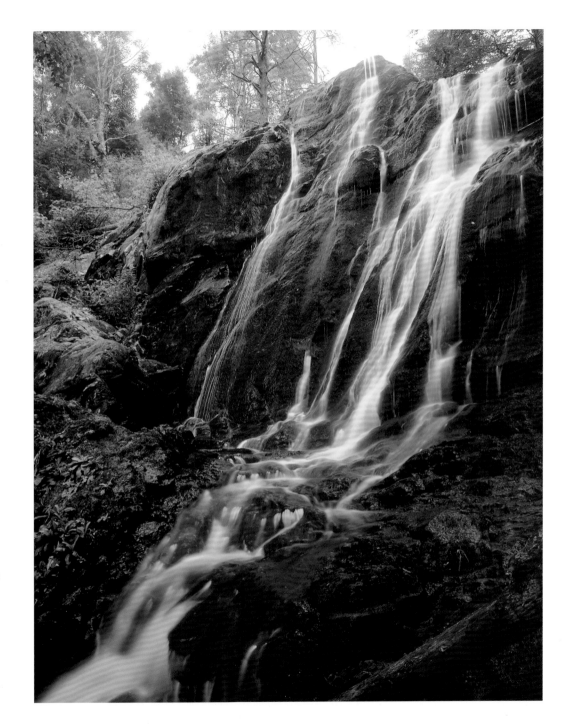

Spring rains feed Dark Hollow
Falls, Big Meadows, Shenandoah
National Parks, Virginia.

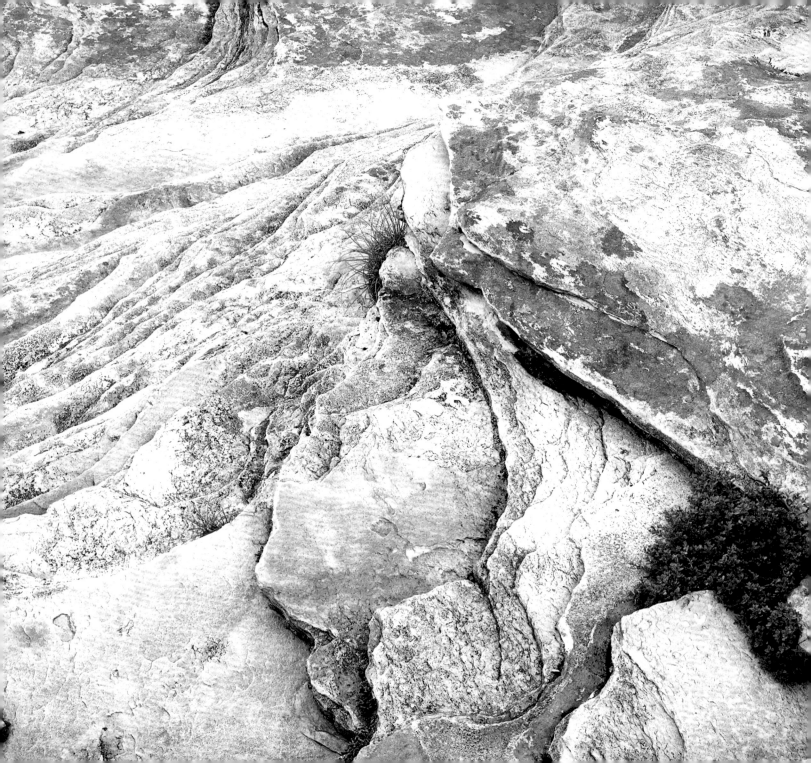

Exposed rock detail at the summit of
Hawksbill Mountain, Linville Gorge
Wilderness in North Carolina.

Iced cascade on the slopes of
Round Bald, Roan Highlands of
Tennessee and North Carolina.

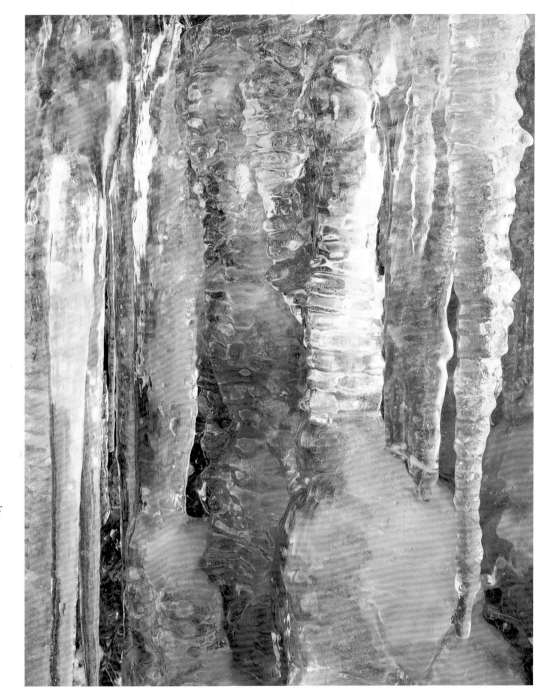

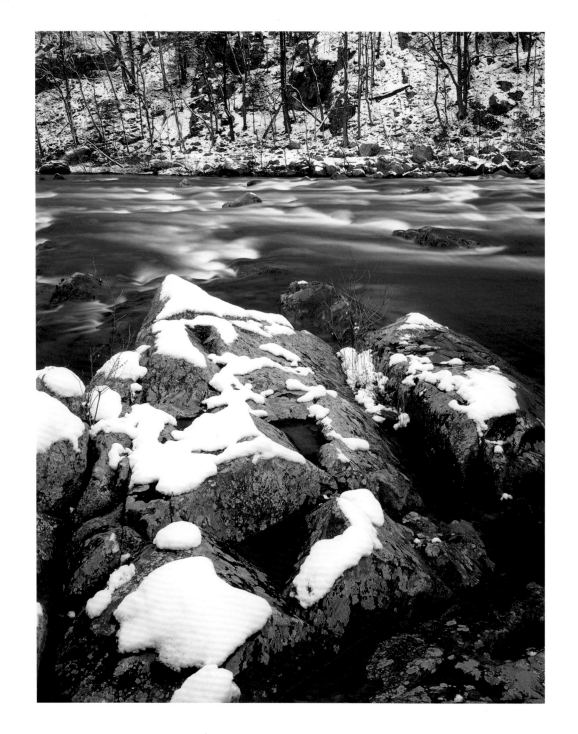

Winter enhances the banks of
the Nolichucky River, Cherokee
National Forest, Tennessee.

Fresh snow blankets Laurel Falls,
Pond Mountain Wilderness,
Tennessee

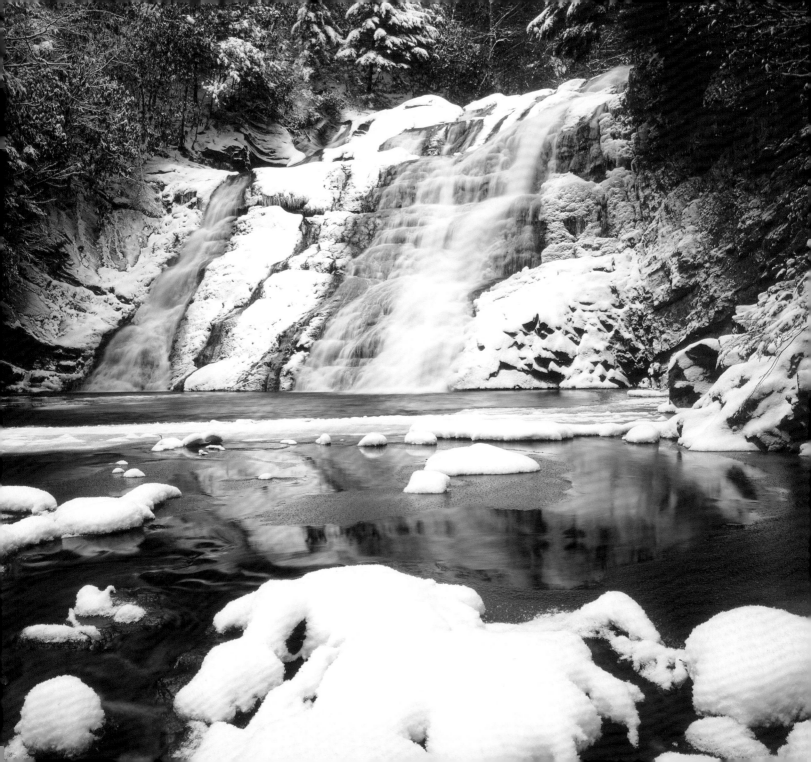

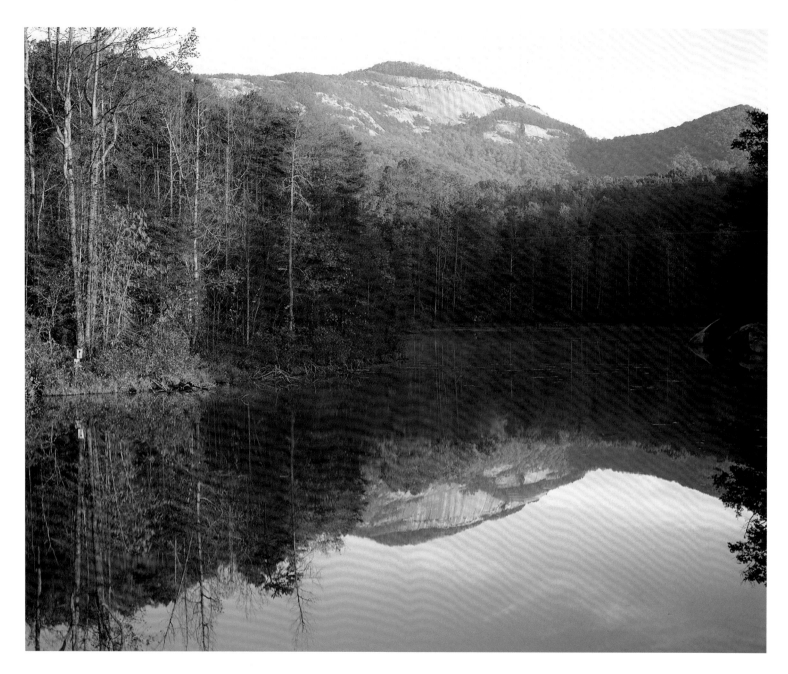

Table Rock reflects its autumn color in Lake Oolenoy,
Table Rock State Park in South Carolina.

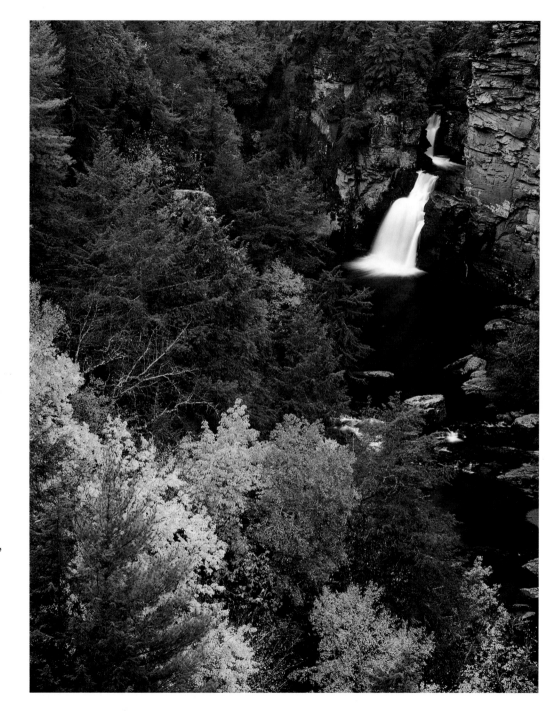

Autumn color adorns Linville Falls,
along the Blue Ridge Parkway in
North Carolina

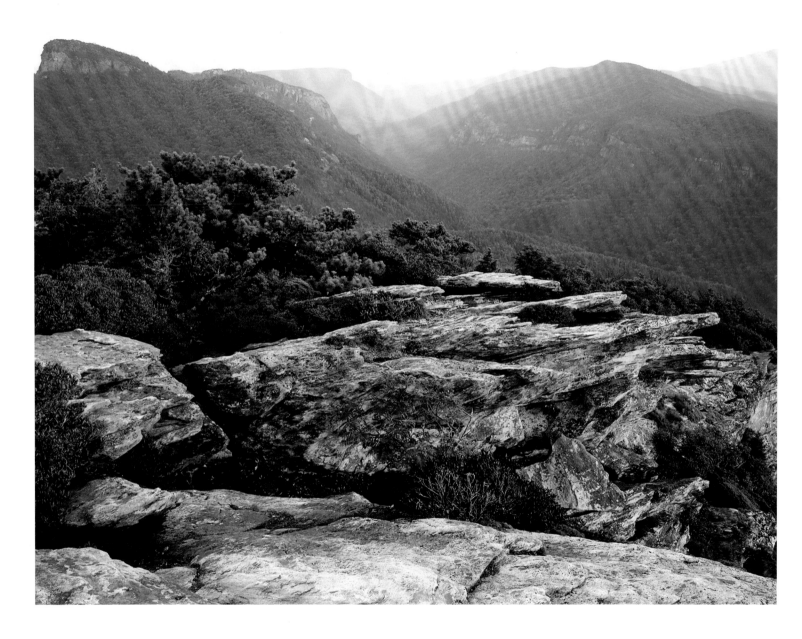

Evening light graces Table Rock Mountain and the cliffs of Linville Gorge,
Linville Gorge Wilderness, North Carolina.

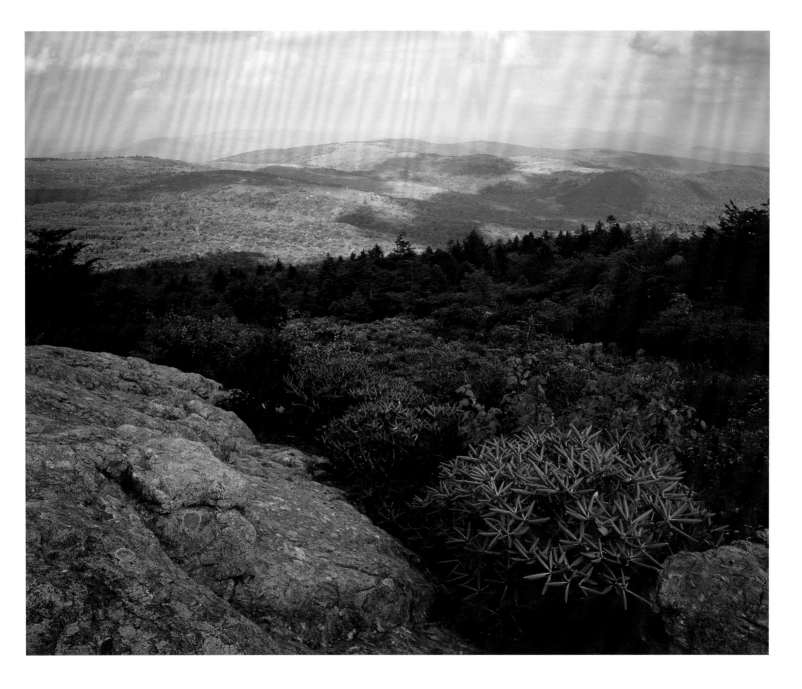

Autumn's touch comes early along the open balds of the Virginia Highlands,
Mount Rogers National Recreation Area, Virginia.

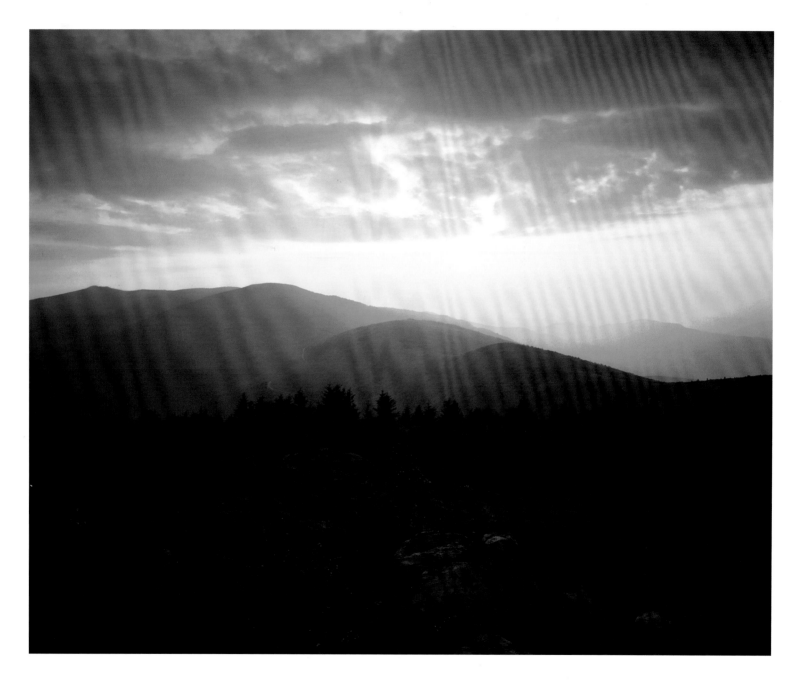

Summer sunset across the Highlands, as viewed from Grassy Ridge Bald,
Roan Highlands of North Carolina and Tennessee.

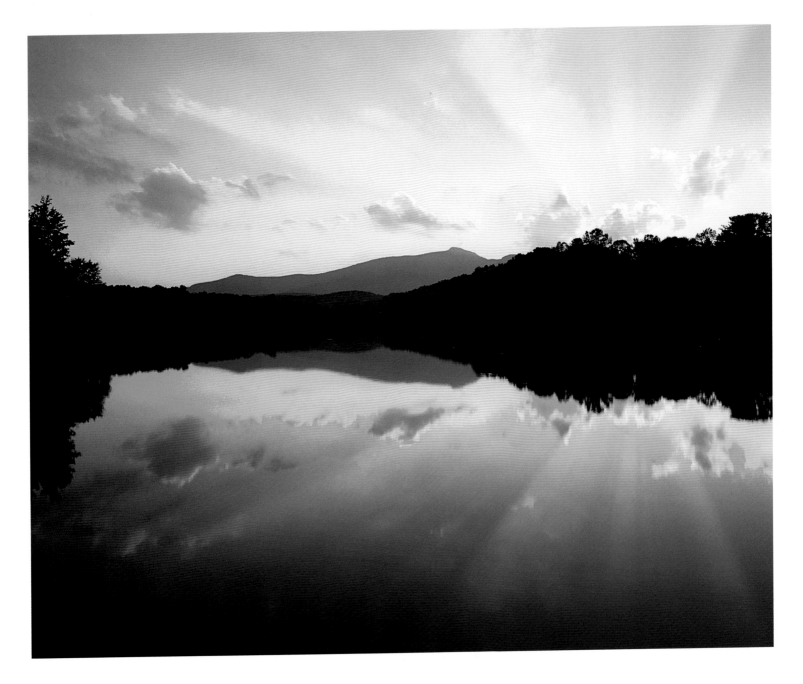

Evenings golden light reflects in the pristine waters of Price Lake, along the
Blue Ridge Parkway in North Carolina.

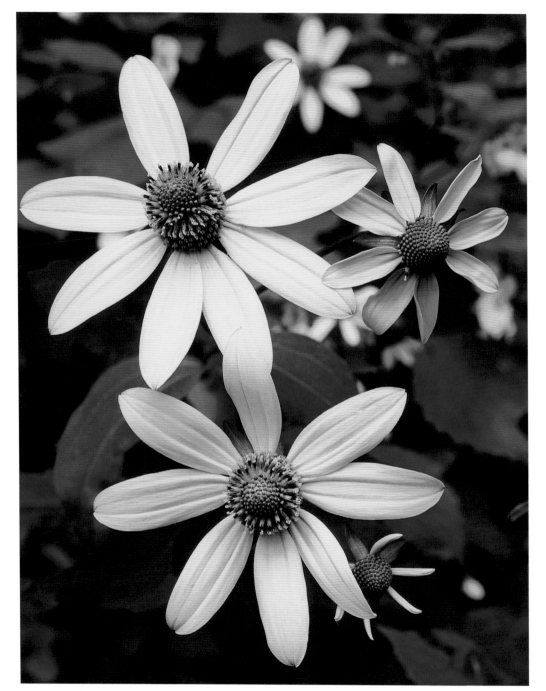

Coneflower grows in abundance along
the valleys of the Chattahoochee
National Forest in Georgia.

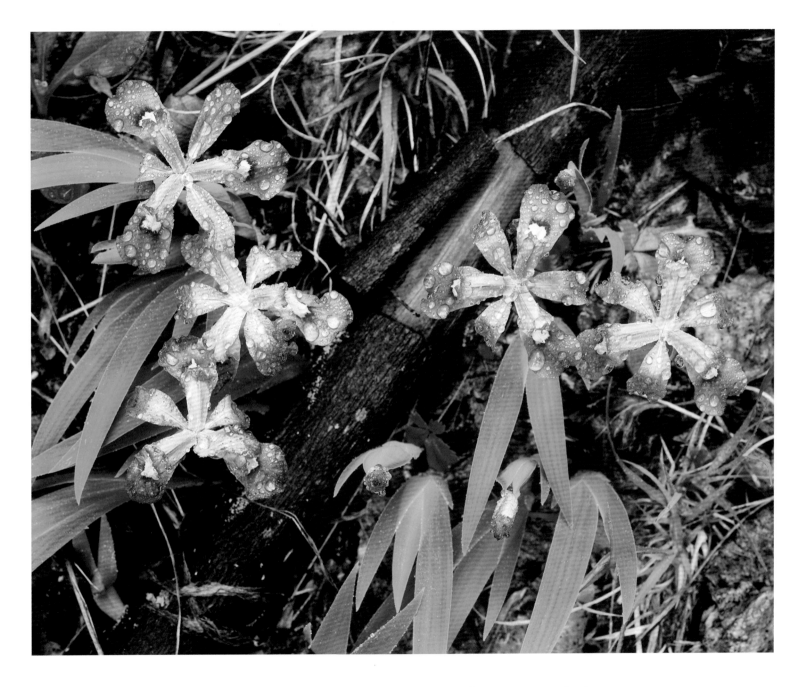

Crested Dwarf Iris flowers proliferate along the mountain trails of
Great Smoky Mountains National Park, Tennessee and North Carolina.

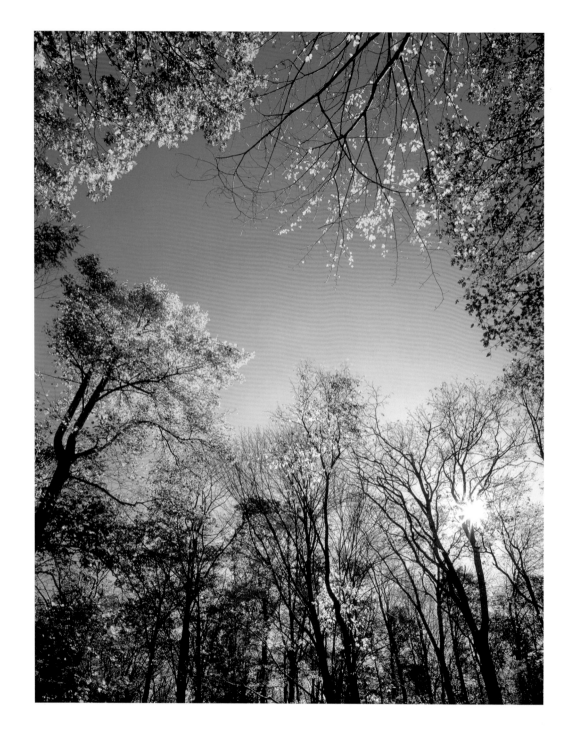

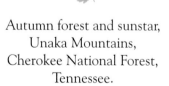

Autumn forest and sunstar,
Unaka Mountains,
Cherokee National Forest,
Tennessee.

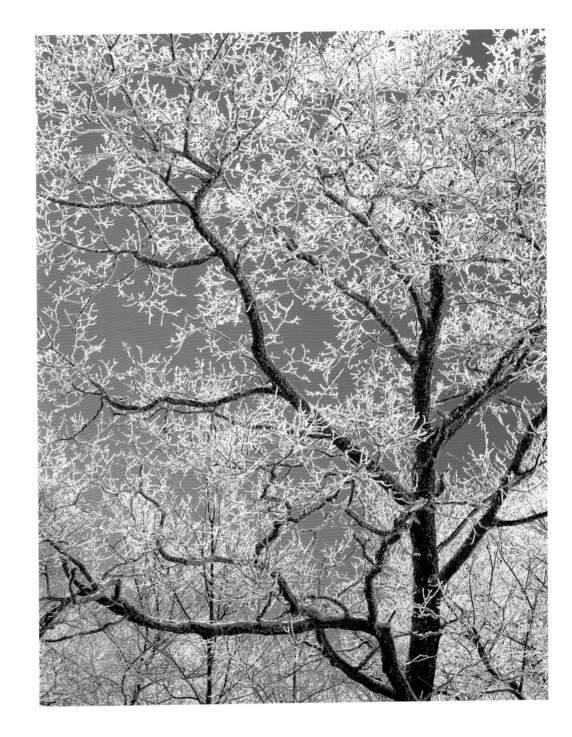

Hoarfrost-shrouded trees,
Unaka Mountains,
Cherokee National Forest,
Tennessee.

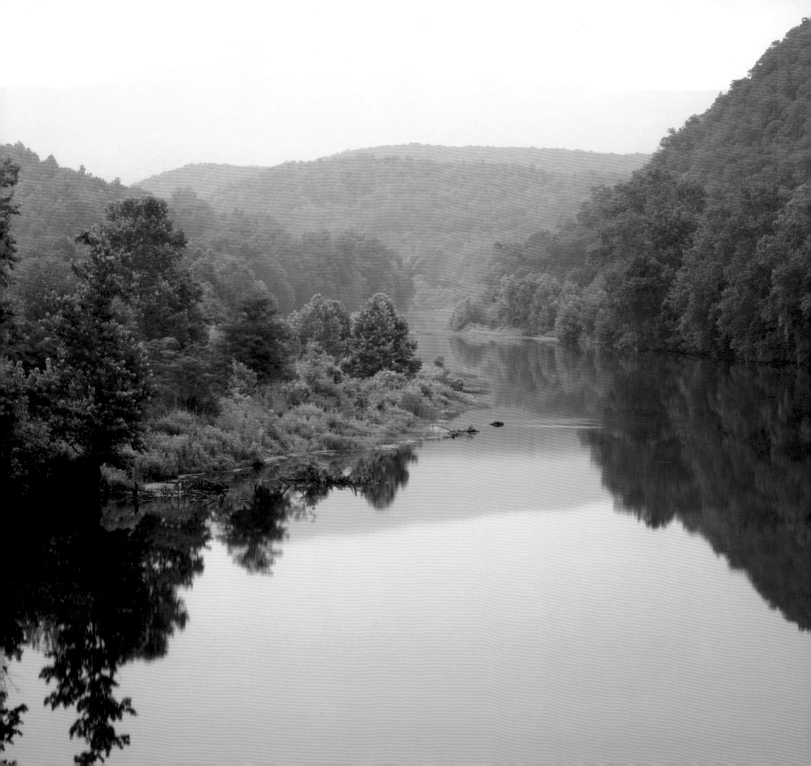

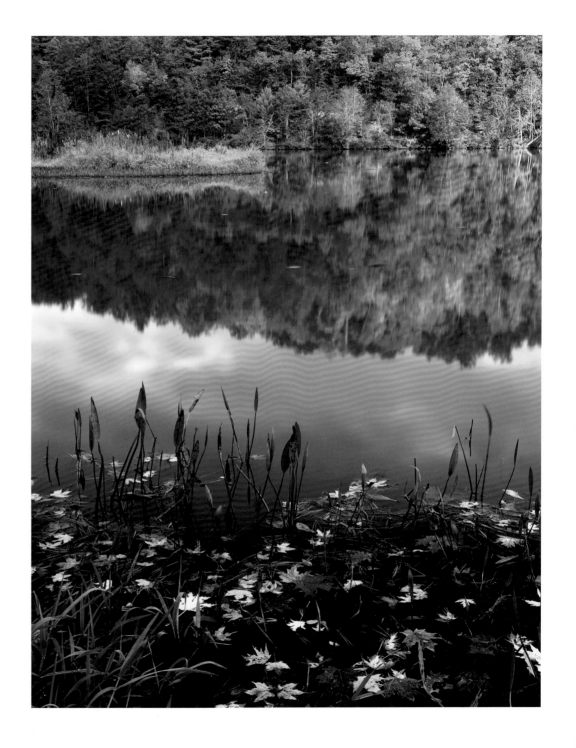

Summer reflects its beauty in the James River, along the Blue Ridge Parkway in Virginia.

The dazzling colors of autumn reflect in the New River, Grayson County, Virginia.

Overleaf: Summer sunset light highlights the wondrous Blue Ridge skyline, Pisgah National Forest of North Carolina.

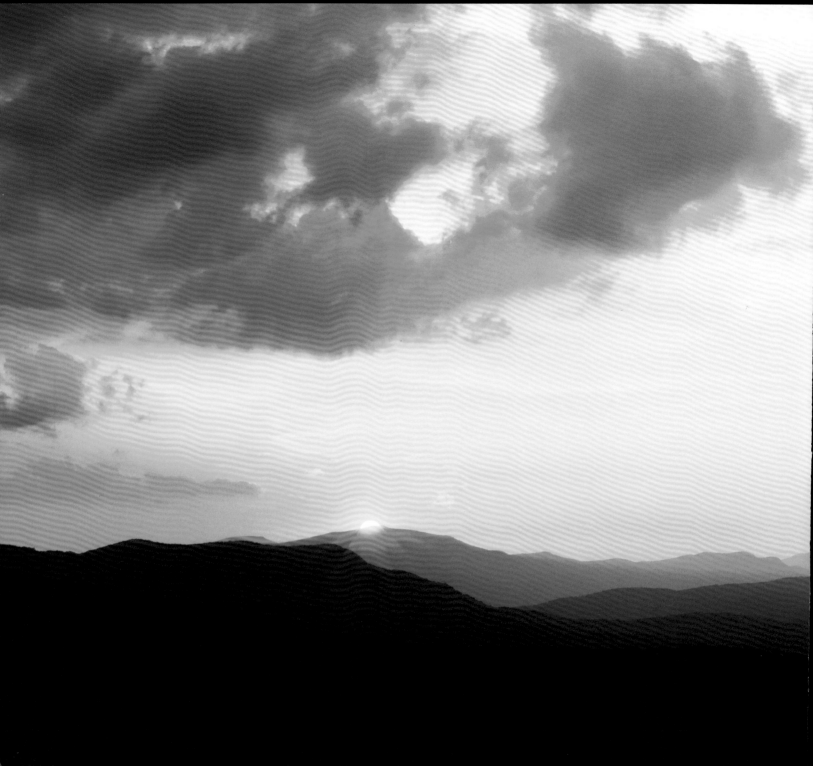

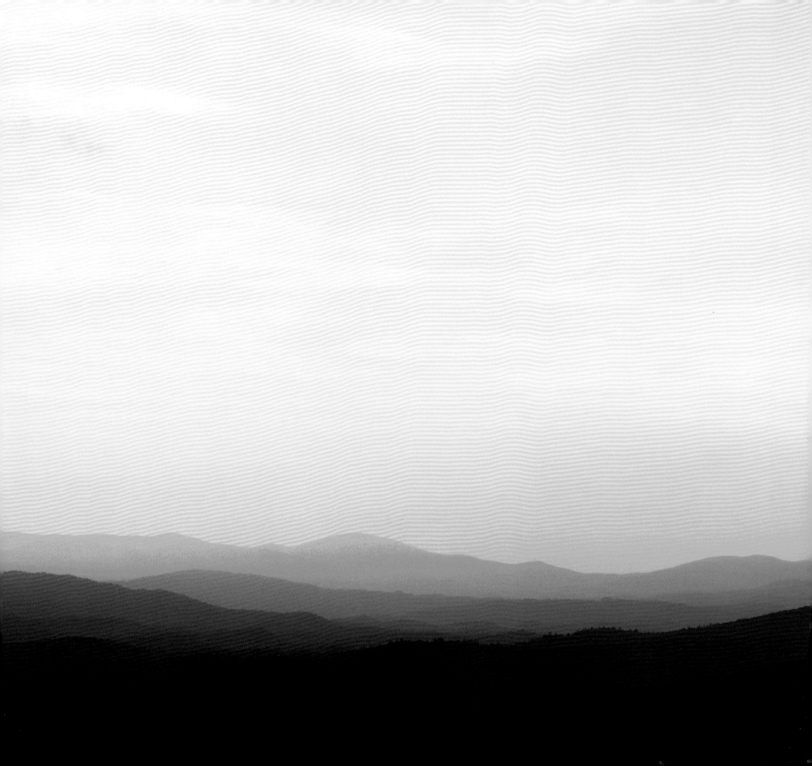

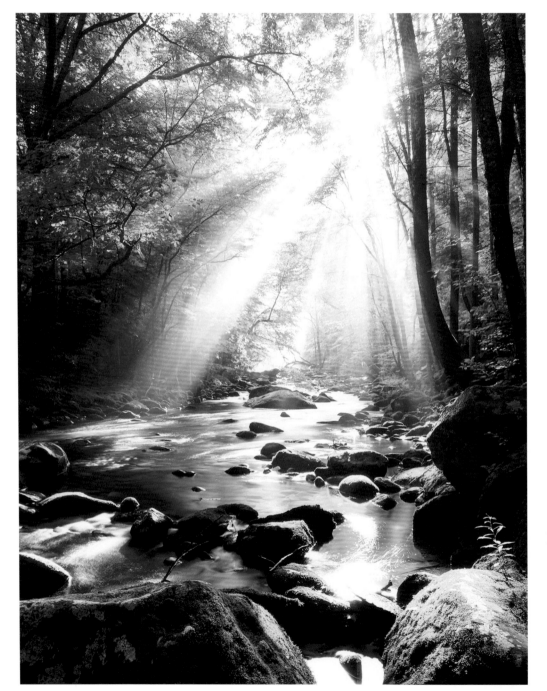

Morning mist and sunbeams along the
Little River at Elkmont, Great Smoky
Mountains National Park, Tennessee
and North Carolina.

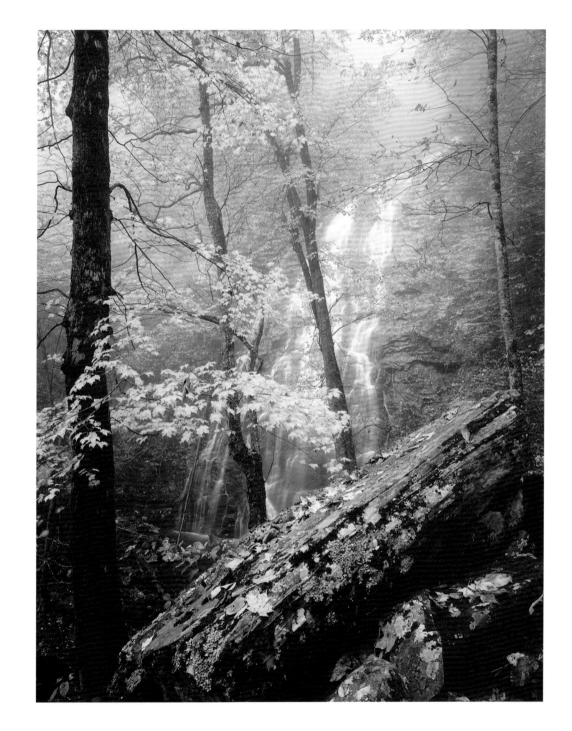

Fog accentuates autumn colors
surrounding Crabtree Falls,
Crabtree Meadows, Blue Ridge
Parkway in North Carolina.

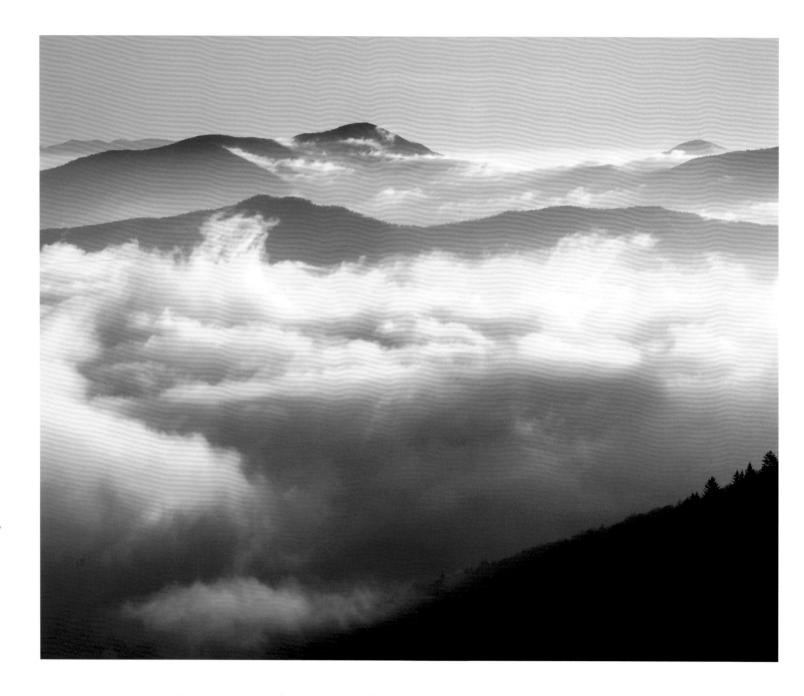

Sunrise over the Shining Rock Wilderness, with Cold Mountain and Mount Pisgah
defining the skyline, Pisgah National Forest, North Carolina

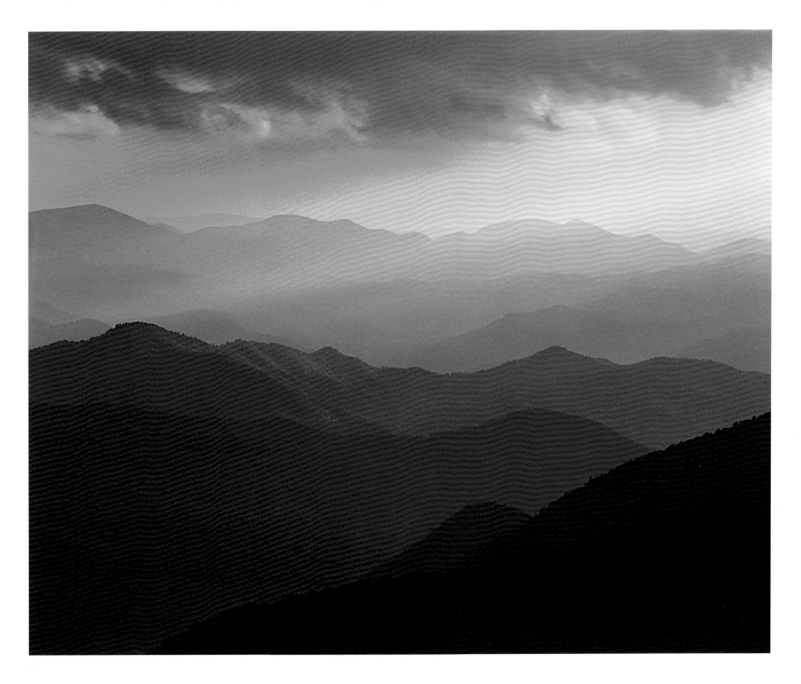

A summer sunset sends shafts of fiery light to illuminate the landscape,
Nantahala National Forest, North Carolina

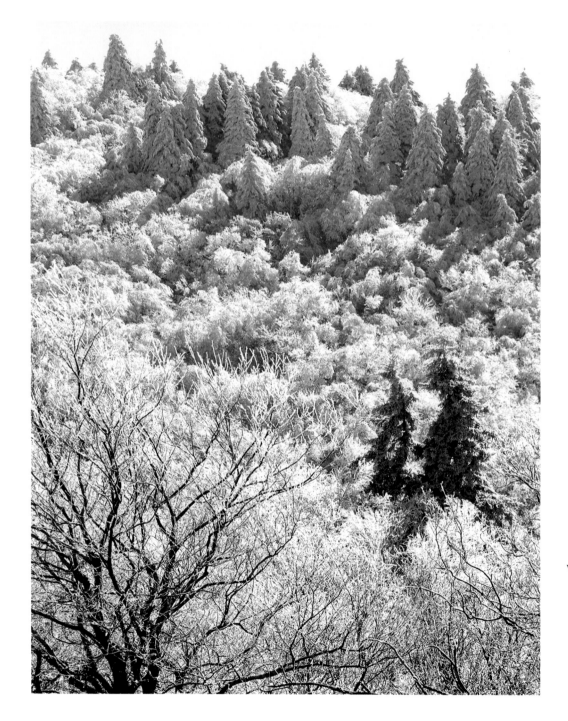

A winter storm conceals the forest
with hoarfrost, Unaka Mountains of
Cherokee National Forest,
Tennessee.

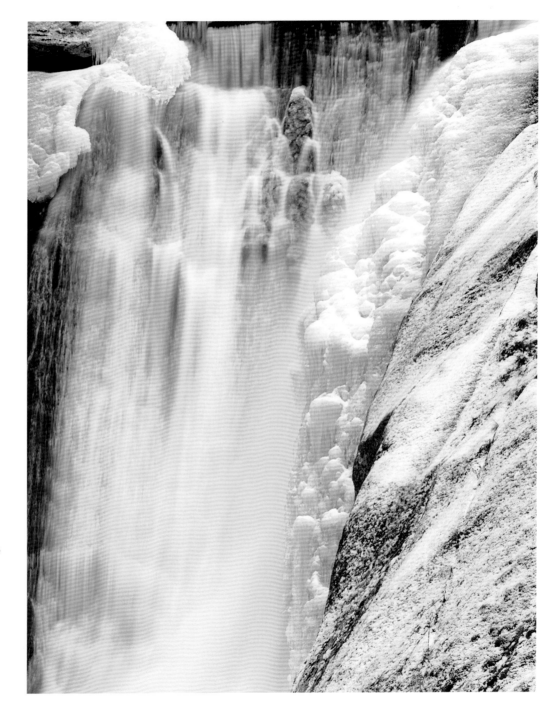

Ice formations accentuate Elk Falls,
Pisgah National Forest,
North Carolina.

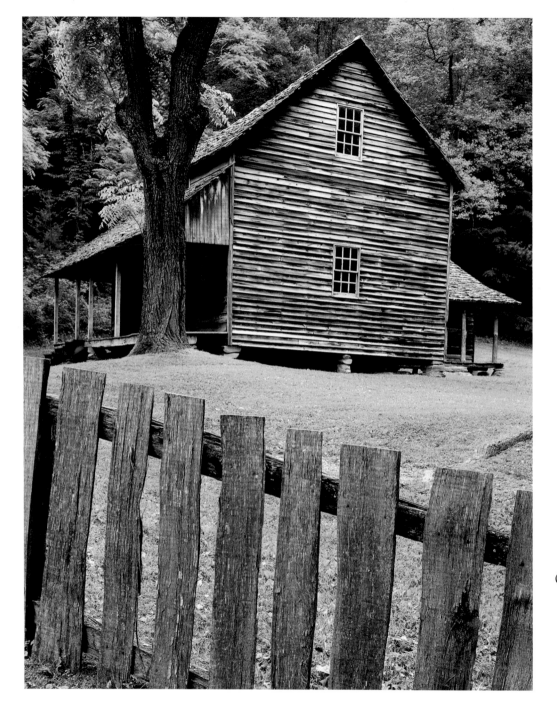

Early summer at the Tipton Place
in Cades Cove,
Great Smoky Mountains National Park,
Tennessee and North Carolina

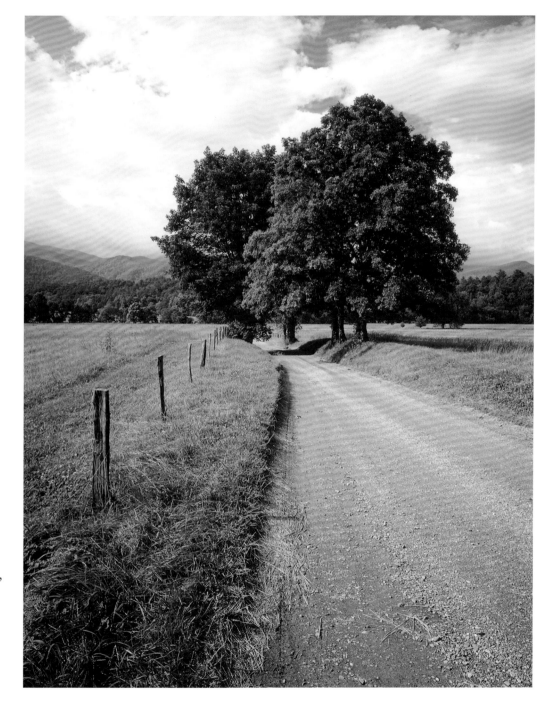

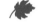

Summertime along Hyatt Lane
in Cades Cove,
Great Smoky Mountains National Park,
Tennessee and North Carolina.

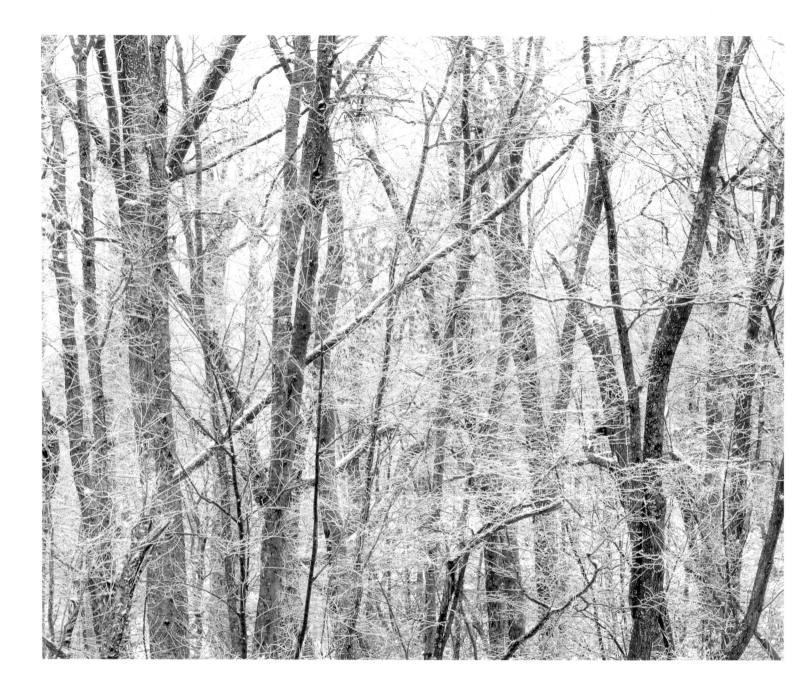

Frosted forest detail, Chattahoochee National Forest, Georgia

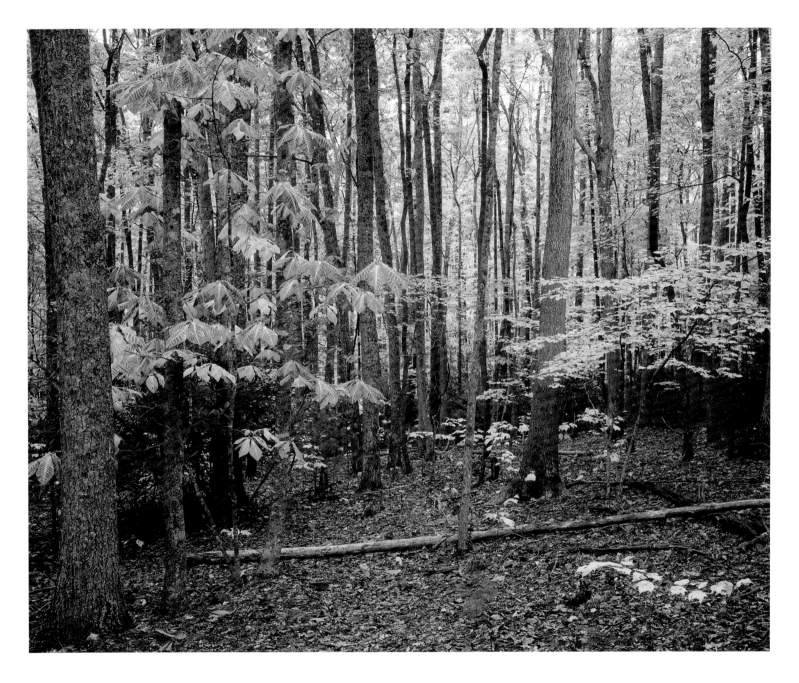

Autumn forest, John R. Dickey Birch Branch Sanctuary in Shady Valley, Tennessee.
Marie Dickey Kalman donated the 452-acre sanctuary to the Tennessee Chapter of the Nature Conservancy in December of 1996.

Pink lady's slipper thrives on a mossy
bolder, Great Smoky Mountains
National Park in Tennessee and
North Carolina.

Wildflower garden, Cove Harwood
Nature Trail, Great Smoky Mountains
National Park in Tennessee and
North Carolina.

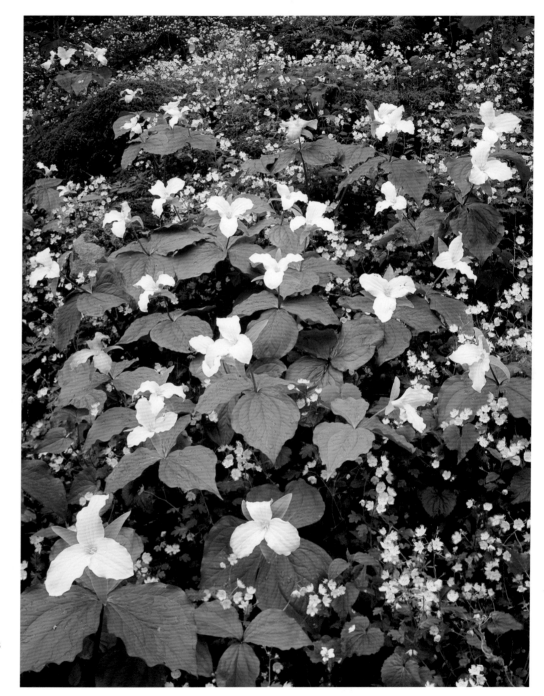

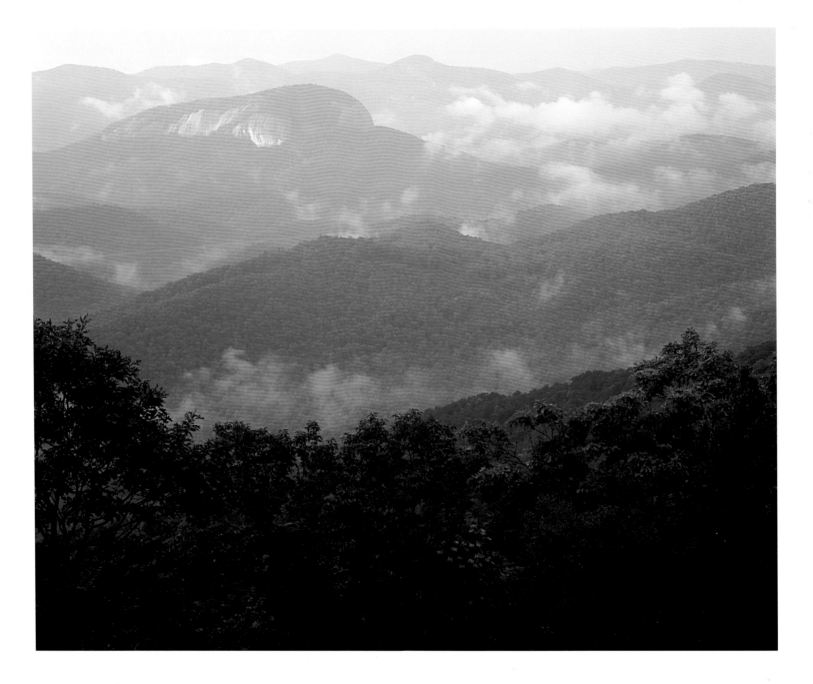

A summer storm over Looking Glass Rock, as viewed from the Blue Ridge Parkway,
Pisgah National Forest, North Carolina

Afterword

Land preservation and protection from the threat of fragmentation and unbridled development is the single most important issue facing the conservation movement in the Blue Ridge for the new millennium. In addition to being home to four of the most important centerpieces of our entire National Park System—the Appalachian Trail, the Blue Ridge Parkway, Shenandoah and Great Smoky Mountains national parks—America's first frontier is blessed with over three million acres of U.S. Forest Service lands. While these southern highlands are endowed with this ecologically rich core of publicly protected areas, the adjoining private lands surrounding them present the greatest challenge, as well as the greatest opportunity, for additional protection for future generations. Jerry Greer has captured the essence and elegance of these crown jewels of our ancient mountain lands like no one else. His work should prove an inspiration to all in the conservation movement as the 21st century emerges.

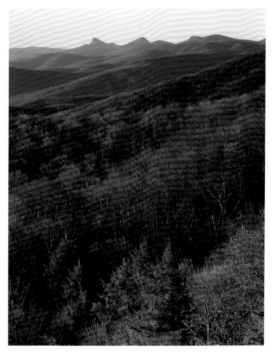

Building upon a plethora of national and regional conservation initiatives, like the early efforts of the Open Spaces Conservancy, the Lands of Boone and Crockett Project of The Land Trust for Tennessee is currently being launched here in the heart of America's first frontier. This unique, voluntary land preservation effort is being created in cooperation with the Appalachian Resource Conservation and Development Council, with the primary goal of protection of threatened farmland, timberland, open spaces, viewsheds and riparian corridors. It is just one of a number of examples in the southern mountain region of the resurgence of that pioneer spirit of the frontier, as a variety of initiatives seeks permanent protection of many of the special places surrounding our existing system of public lands.

It is noteworthy that numerous populations of some of the world's most significant living natural resources are concentrated in such a relatively small area here in the Blue Ridge. Protection from more anthropogenic encroachments is critical for remaining unspoiled areas of biodiversity that are of such immense biological importance to the global environmental community. Other reasons for protection include preservation of an agricultural based community, clean drinking water and outdoor recreation, to name but a few. The various conservation efforts throughout the Blue Ridge epitomize the pioneering spirit of forefathers like Daniel Boone and Davy Crockett; preserving the past—building for the future—still at the frontier.

—Judge Ed E. Williams, III
Unicoi, Tennessee

Acknowledgments

I began work on this project four years ago with only the title and a new camera; it was an awakening for me as a new large-format landscape photographer. I had to learn the process of what makes the view camera work, with its numerous movements such as tilt, swing, rise and fall.

The large-format view camera is a magnificent piece of equipment. My camera is a folding view camera that's hand-crafted of mahogany and titanium. Even though it is of modern manufacture, its leather accordion bellows and beautifully crafted wood body make it look like an antique. The view camera is a beautiful, but cumbersome, artistic tool.

Making landscape photographs with my view camera resembles a forest ballet. The view camera becomes the connection between the landscape and myself. As a large-format landscape photographer, my ultimate goal is to create a photograph that transports the viewer into nature, to capture an image that evokes an emotional reaction, but remains truthful to my personal vision and to the landscape itself.

I use Fujichrome Velvia 50, Velvia 100F, Astia 100F and Kodak E100VS film. My camera of choice is an Ebony RW45, and I use lenses from Schneider, Fujinon and Rodenstock that range from 65mm to 360mm. Exposures are calculated on a Sekonic L-508 meter. Filters used are from Singh-Ray, including Hi-lux, CC5M, polarizer and various graduated neutral density filters. To steady my camera for general photography I use a Ries J-600 wooden tripod; for backpacking I use a Manfrotto Carbon One 441 tripod. I use a Kirk BH-1 ball head on both.

I would like to extend a very special thank you to my friend Donald Davis, a magnificent storyteller, for writing the foreword for this book. His childhood stories of growing up in these Blue Ridge Mountains have opened a new chapter in my life as a landscape photographer, and as a native of the Southern Appalachians. I'm so glad to be back in these mountains! I am especially grateful to Ed Williams for writing the afterword. The hard work he pursues with the forest service and the many Southern Appalachian conservation groups is wonderful. We need many more people to follow in his footsteps. Thanks, again, to my best friend, Todd Caudle, for guiding me through this wonderful profession we call nature photography! I'm forever indebted. Thanks to all of the conservation groups that work so tirelessly to protect our Southern Appalachian Mountains. Finally, and most of all, thank you to my wife, Angela, for supporting me in life and all my photographic endeavors.

—Jerry D. Greer

Fine art editions of the photographs in this book are available for sale. Those interested in purchasing prints may visit Jerry's website at www.jerrygreerphotography.com or in writing at Jerry Greer Photography, 1818 Presswood Road, Johnson City, TN, 37604.